LETTERHEAD &
LOGO
DESIGN 10

ROCKPORT

© 2007 by Rockport Publishers, Inc.
Paperback edition published in 2009

First published in the
United States of America by
Rockport Publishers, a member of
Quayside Publishing Group
100 Cummings Center
Suite 406-L
Beverly, MA 01915-6101
Telephone: (978) 282-9590
Fax: (978) 283-2742
www.rockpub.com

ISBN-13: 978-1-59253-579-8
ISBN-10: 1-59253-579-8

10 9 8 7 6 5 4 3 2 1

Design: Sussner Design Company
Photography: Creative Publishing International

Printed in China

LETTERHEAD & LOGO DESIGN 10

DESIGN **10**

SUSSNER DESIGN CO.

BEVERLY MASSACHUSETTS

ROCKPORT PUBLISHERS

CONTENTS

INTRODUCTION 8 THE WORK 18 DIRECTORY 230

67 - AUSTRALIA
69 - CANADA
1 - CROATIA
21 - DENMARK
36 - ECUADOR
87 - GERMANY
1 - GREECE
8 - HONG KONG
3 - ICELAND
16 - ITALY
6 - LEBANON
1 - MEXICO
9 - NETHERLANDS
19 - NEW ZEALAND
1 - PORTUGAL
12 - SINGAPORE
33 - SLOVENIA
1 - SWITZERLAND
12 - TAIWAN
11 - UKRAINE
18 - UNITED KINGDOM

102 FIRMS ARE REPRESENTED IN THE BOOK

22 COUNTRIES SUBMITTED

2,364 EN

82%
U.S. SUBMISSIONS

AVERAGE ENTRY PER STAT

1,932 U.S.

442 INTERNATIONAL

2 - ALABAMA; 29 - ALASKA; 4 - ARIZONA; 159 - CALIFORNIA; 22 - COLORADO; 16 - CONNECTICUT; 26 - FLORIDA; 22 - GEOR
1 - LOUISIANA; 1 - MAINE; 34 - MARYLAND; 68 - MASSACHUSETTS; 24 - MICHIGAN; 429 - MINNESOTA; 102 - MISSOURI;
9 - NEW MEXICO; 83 - NEW YORK; 73 - NORTH CAROLINA; 82 - OHIO; 6 - OKLAHOMA; 84 - OREGON; 86 - PENNSYLVANIA; 2 - RI
15 - VERMONT; 10 - VIRGINIA; 92 - WASHINGTON; 24 - WASHINGTON, DISTRICT OF COLUMBIA; 11 WEST VIRGINIA; 31 - WISCONS

18%

INTERNATIONAL SUBMISSIONS

TRIES

= 46

288 SELECTED ENTRIES

ENTRIES 41 U.S.

STATES SUBMITTED

TRIES

318 FIRMS SUBMITTED WORK

9 STATES DID NOT SUBMIT WORK FROM THE U.S. ARKANSAS DELAWARE HAWAII IDAHO MISSISSIPPI MONTANA NORTH DAKOTA SOUTH DAKOTA WYOMING

10

LATE ENTRIES

AVERAGE SUBMISSIONS = 7.4 PER FIRM

258 U.S. ENTRIES MADE IT IN THE BOOK

- ILLINOIS; 28 - INDIANA; 150 - IOWA; 38 - KANSAS; 8 - KENTUCKY;
EBRASKA; 13 - NEVADA; 4 - NEW HAMPSHIRE; 37 - NEW JERSEY;
LAND; 2 - SOUTH CAROLINA; 28 - TENNESSEE; 17 - TEXAS; 25 - UTAH;

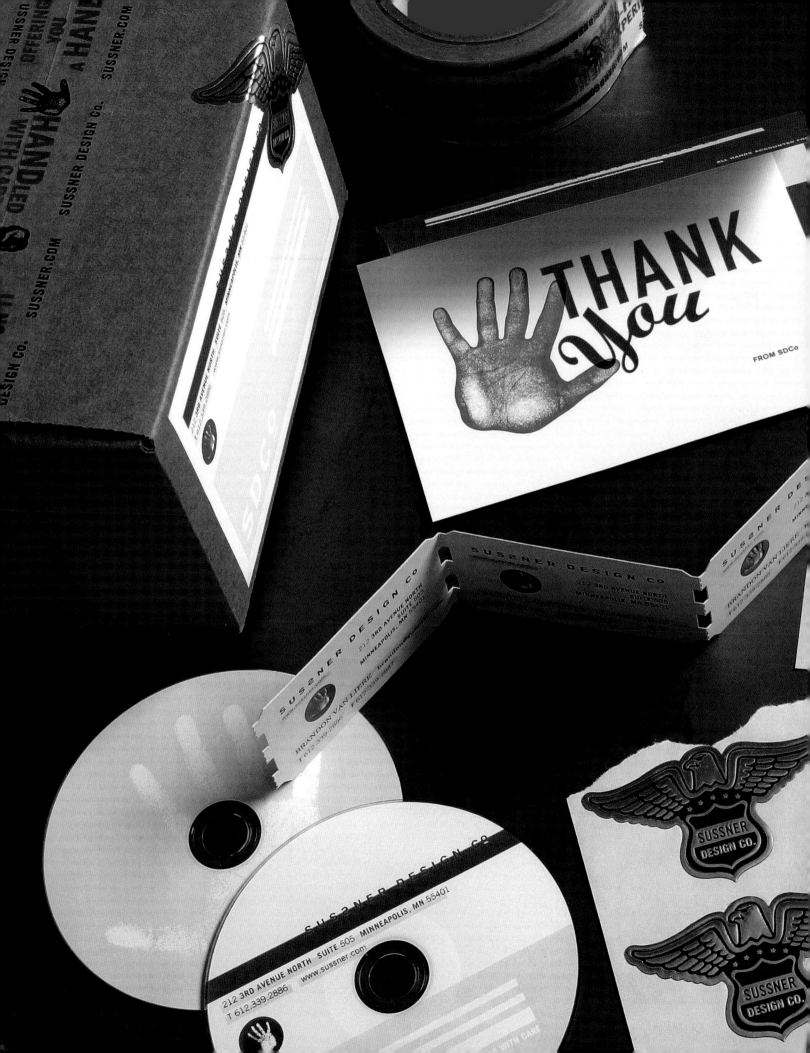

AUTHOR **SDCo**

A FIRM GRIP ON REALITY.

THE HUMAN HAND DOMINATES THE SUSSNER DESIGN COMPANY (SDCO) BRAND IMAGE. A PALM WITH FOUR FLEXIBLE FINGERS AND ONE OPPOSABLE THUMB HAS OBVIOUS AFFINITY WITH WELL-CRAFTED, INTELLIGENT DESIGN WORK. **AN IMAGE MANIFESTED BY THE PERSONAL APPROACH, THE HUMAN TOUCH, THE ATTENTION TO DETAIL, AND THE BIG, FRIENDLY "HELLO" TO CLIENTS READY TO ENGAGE IN A GENUINE HAND-IN-HAND PARTNERSHIP.** THE HAND REPRESENTS AN **AUTHENTIC WORK ETHIC** AND A DISTINCT **SHADE OF BLUE-COLLAR** FROM A SHOP THAT MAKES AN HONEST EFFORT TO UNDERSTAND THE REALITIES OF EACH CLIENT/PARTNER. AT SDCO, **"HANDS-ON"** AND **"COLLABORATIVE"** ARE NOT VACANT MARKETING QUIPS; THEY **ARE THE GUIDELINES FOR EVERY PROJECT AND EVERY CLIENT.**

SDCO'S WORK HAS BEEN RECOGNIZED BY LEADING DESIGN PUBLICATIONS SUCH AS *PRINT, HOW, GRAPHIS,* **AND** *COMMUNICATION ARTS,* **AND BY SUCH** ORGANIZATIONS AS TYPE DIRECTORS CLUB, MEAD 60, AIGA MINNESOTA, MIDWEST DIRECT MARKETING ASSOCIATION, AND MORE.

SDCO IS A MINNEAPOLIS FIRM FIRMLY PLANTED SINCE 1999. THE ORIGINAL COMPANY OF SOLO SUSSNER (A.K.A. DEREK) HAS PROGRESSED INTO A GROUP OF TALENTED, LIKEMINDED PROFESSIONALS WORKING TO MAKE SUSSNER DESIGN COMPANY REFLECTIVE OF THE SUSSNER–**BIG ON DESIGN** AND **PROUD OF THE COMPANY.**

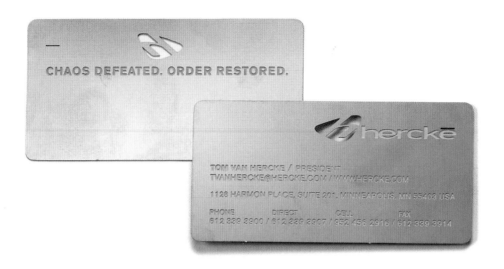

CHAOS DEFEATED. ORDER RESTORED.

hercke

TOM VAN HERCKE / PRESIDENT
TVANHERCKE@HERCKE.COM / WWW.HERCKE.COM

1128 HARMON PLACE, SUITE 201, MINNEAPOLIS, MN 55403 USA

PHONE DIRECT CELL FAX
612.339.3900 / 612.339.3907 / 952.456.2916 / 612.339.3914

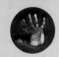 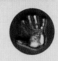 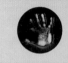

S U S ƨ N E R D E S I G N C⁰
www.sussner.com

212 **3RD AVENUE NORTH**
SUITE 505
MINNEAPOLIS, MN 55401

BRANDON VAN LIERE brandon@sussner.com

T 612-339-2886 **F** 612-339-2887

S U S ƨ N E R D E S I G N C⁰
www.sussner.com

212 **3RD AVENUE NORTH**
SUITE 505
MINNEAPOLIS, MN 55401

BRANDON VAN LIERE brandon@sussner.com

T 612-339-2886 **F** 612-339-2887

S U S ƨ N E
www.sussner.com

BRANDON VAN

T 612-339-2886

k keys to...

lynnae m. haines

Keys to . . . , LLC
p.o. box 16188
minneapolis, mn 55416-0188

voice: 952/345.8250
fax: 952/345.8251
toll-free: 866/KEYS24U

keysto.com lhaines@keysto.com

open the door

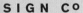

SIGN Co

3RD AVENUE NORTH
SUITE 505
EAPOLIS, MN 55401

randon@sussner.com
2887

SUSSNER DESIGN Co
www.sussner.com

212 **3RD AVENUE NORTH**
SUITE 505
MINNEAPOLIS, MN 55401

BRANDON VAN LIERE brandon@sussner.com

T 612-339-2886 **F** 612-339-2887

SDCO

YOU HAVE MY HAND ON IT

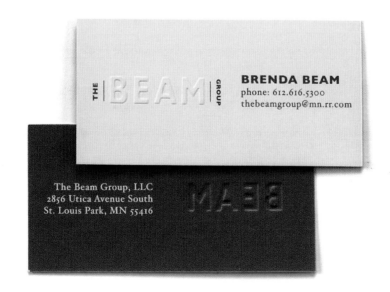

THE **BEAM** GROUP

BRENDA BEAM
phone: 612.616.5300
thebeamgroup@mn.rr.com

The Beam Group, LLC
2856 Utica Avenue South
St. Louis Park, MN 55416

BEAM

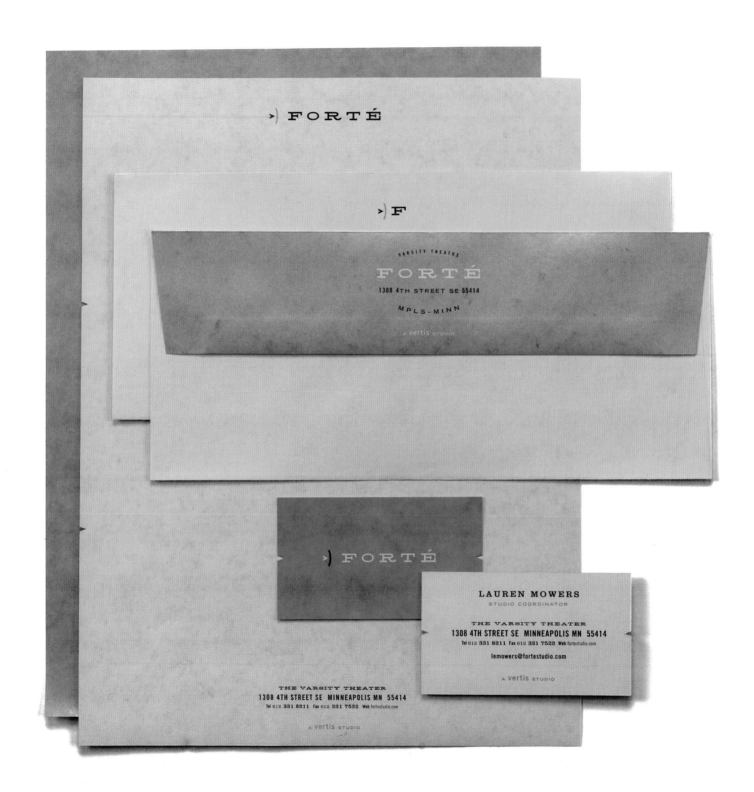

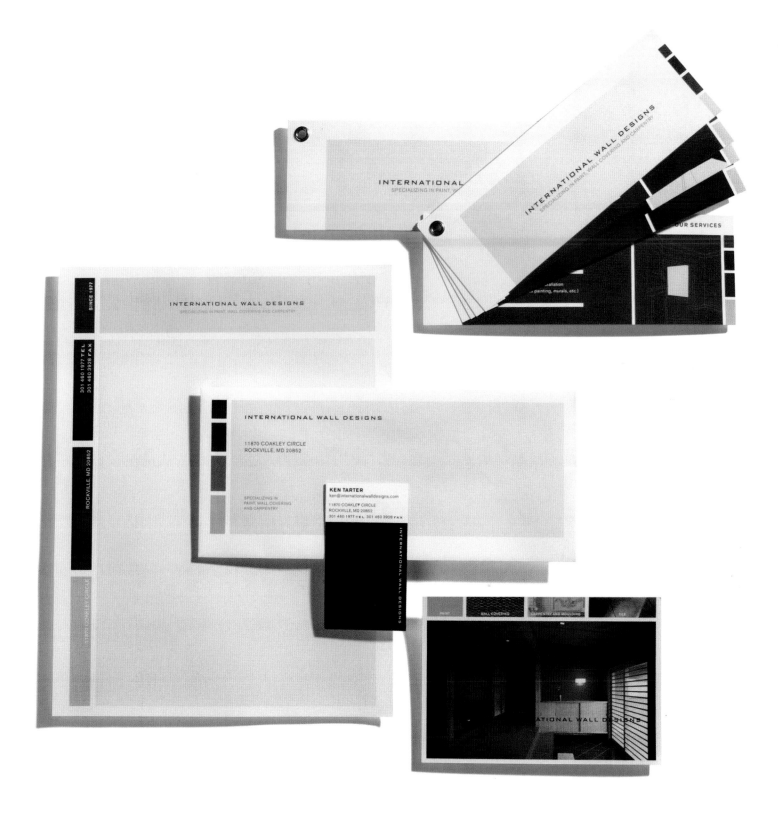

REFLECTIONS

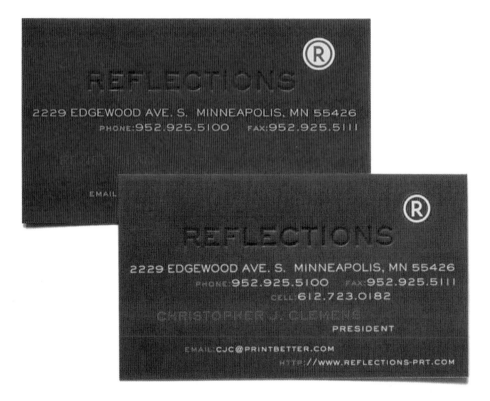

REFLECTIONS

2229 EDGEWOOD AVE. S. MINNEAPOLIS, MN 55426
PHONE:952.925.5100 FAX:952.925.5111

EMAIL

REFLECTIONS

2229 EDGEWOOD AVE. S. MINNEAPOLIS, MN 55426
PHONE:952.925.5100 FAX:952.925.5111
CELL:612.723.0182

CHRISTOPHER J. CLEMENS
PRESIDENT

EMAIL:CJC@PRINTBETTER.COM
HTTP://WWW.REFLECTIONS-PRT.COM

THE WORK

HITTING THE MARK.

WE ARE ONE DESIGN FIRM AND A HANDFUL OF DESIGNERS WITH VARIED OPINIONS, PREDISPOSITIONS, TASTES, TOLERANCES, AND JUST ODD, UNEXPLAINABLE HABITS THAT FREQUENTLY CONCERN OUR FAMILIES. WITH THAT IN MIND, WE WERE ASKED TO SELECT THE LETTERHEAD AND LOGO ENTRIES THAT INHABIT THIS BOOK. THIS IS NOT AN AWARD SHOW. NO CROWNS, SASHES OR STATUETTES WILL BE HANDED OUT. THIS IS A BOOK POPULATED BY **DAMN GOOD WORK.** USE IT AS A **REFERENCE**, AN **INSPIRATION**, A SIGN THAT **CREATIVITY** WITH PURPOSE IS STILL A **SWEET AND TREASURED THING**.

WE ARE **SUSSNER DESIGN COMPANY.** OUR IDENTITY IS ROOTED IN OPENNESS, TRUST, AND A DOLLOP OF QUIET CONFIDENCE. IN OUR MINDS **A GREAT LOGO IS** AN **EFFECTIVE**, **MEMORABLE**, AND **COMPELLING** REQUEST. **EFFECTIVE**—IN ITS ABILITY TO COMMUNICATE THE ESSENCE OF YOUR IDENTITY. **MEMORABLE**—IN ITS PERSISTENT POWER TO RISE ABOVE THE CLUTTER OF COMMERCE. **COMPELLING**—IN ITS CAPACITY TO SELL YOUR PRODUCT, YOUR SERVICE, AND YOUR BRAND. THE BEST MARKS BREAK THROUGH IN ASSORTED SIZES, VARIED MEDIUMS, MULTIPLE DIMENSIONS, AND IN BLACK AND WHITE. **A GREAT LOGO IS AN IRRESISTIBLE INVITATION.**

FOR THE PURPOSE OF THIS PROJECT, BUSINESS CHALLENGES, OBJECTIVES, AND RESULTS COULD NOT REALISTICALLY FACTOR. SO THAT LEFT US WITH AESTHETICS, MOJO, VIBE, AND ALL THE PREJUDICES LISTED IN OUR VERY FIRST SENTENCE. **SUBJECTIVE? ABSOLUTELY.** IF WE WERE MOVED BY A PIECE, WE MOVED IT STRAIGHT TO THE "A" BOX.

WITHIN THESE PAGES ARE THE 300 LETTERHEADS AND LOGOS THAT RATTLED OUR COLLECTIVE CAGE AND DEMANDED ENTRY INTO THE BOOK. THE PROCESS WAS EXHILARATING AND SURPRISINGLY FUN. WE APPRECIATE THE OPPORTUNITY, WE THANK ALL THOSE WHO SUBMITTED WORK, AND WE CONGRATULATE THE FEATURED DESIGNERS.

N⁰ **0035**
COMMISSAIR

274-4888 | 5226, boul. St-Laurent, Montréal, QC h2t 1s1

N⁰ **0095**
COMMISSAIR

74-4888 | 5226, boul. St-Laurent, Montréal, QC h2t 1s1

N⁰ **0155**
COMMISSAIR

74-4888 | 5226, boul. St-Laurent, Montréal, QC h2t 1s1

Nº 0440
COMMISSAIRES

Nº 0035
COMMISSAIRES

joscelepage@commissairesonline.com т. 514 274-4888 5226, boul. St-Laurent, Montréal, QC h2t 1s1

Nº 0095
COMMISSAIRES

joscelepage@commissairesonline.com т. 514 274-4888 5226, boul. St-Laurent, Montréal, QC h2t 1s1

Nº 0155
COMMISSAIRES

joscelepage@commissairesonline.com т. 514 274-4888 5226, boul. St-Laurent, Montréal, QC h2t 1s1

Nº 0183
COMMISSAIRES

5226, boul. St-Laurent, Montréal, QC h2t 1s1

DESIGN CO.
PAPRIKA

ART DIRECTOR
LOUIS GAGNON

DESIGNER
DAVID GUARNIERI

CLIENT
COMMISSAIRES

blurt™

DESIGN CO.
GO WELSH

ART DIRECTOR
CRAIG WELSH

DESIGNER
VIRGINIA WELSH & RYAN SMOKER

CLIENT
BLURT

1

b.younq®

DESIGN CO.
DESIGNBOLAGET

ART DIRECTOR
CLAUS DUE

DESIGNER
CLAUS DUE

CLIENT
B-YOUNG

2

DESIGN CO.
SEGURA INC.

3

flashbelt

1

ignite

2

catalyst⁺

DESIGN CO.
EIGHTHOURDAY

ART DIRECTOR
KATIE KIRK & NATHAN STRANDBERG

DESIGNER
KATIE KIRK & NATHAN STRANDBERG

CLIENT
FLASHBELT

DESIGN CO.
HARTFORD DESIGN

ART DIRECTOR
TIM HARTFORD

DESIGNER
RON ALIKPALA

CLIENT
IGNITE

DESIGN CO.
SEGURA INC.

3

1

DESIGN CO.
GO WELSH

ART DIRECTOR
CRAIG WELSH

DESIGNER
MIKE GILBERT

CLIENT
ARMSTRONG

DESIGN CO.
BR: VERSE

ART DIRECTOR
NATHANIEL COOPER

DESIGNER
NATHANIEL COOPER

CLIENT
ADVERTISING ICON MUSEUM

2

1

NECC

2

DESIGN CO.
RICKABAUGH GRAPHICS

ART DIRECTOR
ERIC RICKABAUGH

DESIGNER
ERIC RICKABAUGH

CLIENT
DUQUESNE DUKES

DESIGN CO.
DOTZERO DESIGN

DESIGNER
JON WIPPICH & KAREN
WIPPICH

CLIENT
NECC

1

DESIGN CO.
DESIGN ARMY

ART DIRECTOR
JAKE LEFEBURE & PUM LEFEBURE

DESIGNER
TIM MADLE

CLIENT
LADY CHLOE

2

DESIGN CO.
A3 DESIGN

ART DIRECTOR
ALAN ALTMAN

DESIGNER
AMANDA ALTMAN

CLIENT
HIT WOMAN PRODUCTIONS

DESIGN CO.
CUE, INC.

ART DIRECTOR
ALAN COLVIN

DESIGNER
ALAN COLVIN

CLIENT
DADS & DAUGHTERS

3

1

DESIGN CO.
MINE™

ART DIRECTOR
CHRISTOPHER SIMMONS

DESIGNER
CHRISTOPHER SIMMONS

CLIENT
SF RED DEVILS

2

DESIGN CO.
FAUXKOI DESIGN CO.

DESIGNER
DAN WEST

CLIENT
CATLICK RECORDS

DESIGN CO.
PBJS

ART DIRECTOR
JOHN HARPER

DESIGNER
ERIC WYTTENBACH

CLIENT
PBJS

3

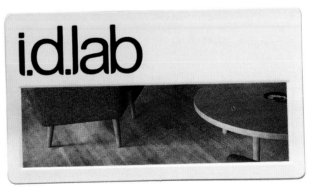

DESIGN CO.
KINETIC

ART DIRECTOR
PANN LIM & ROY POH

DESIGNER
PANN LIM

CLIENT
I.D. LAB

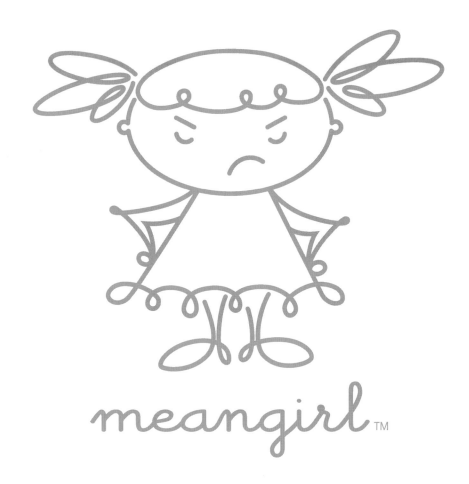

DESIGN CO.
DESIGN RANCH

ART DIRECTOR
INGRED SIDIE & MICHELLE SONDEREGGER

DESIGNER
MICHELLE SONDEREGGER

CLIENT
MEANGIRL

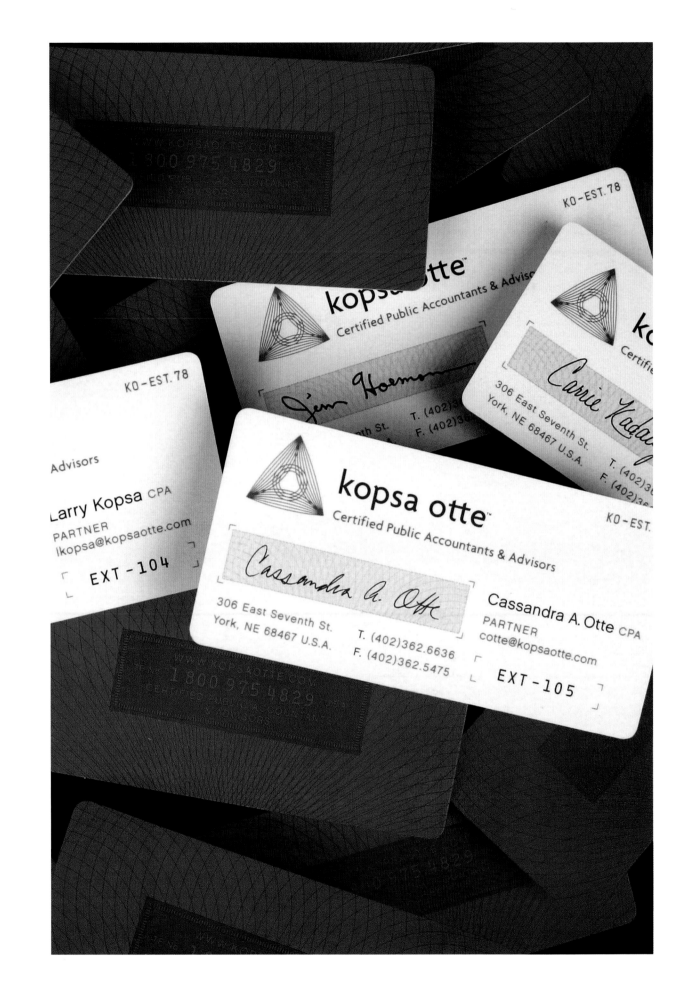

DESIGN CO.
ARCHRIVAL

DESIGNER
JOEL KREUTZER

CLIENT
KOPSA OTTE

1

2

DESIGN CO.
DESIGN RANCH

ART DIRECTOR
INGRED SIDIE & MICHELLE SONDEREGGER

DESIGNER
TAD CARPENTER & MICHELLE MARTYNOWICZ

CLIENT
COUNTERPUNCH TRADING

DESIGN CO.
SYNERGY GRAPHIX

ART DIRECTOR
REMO STRADA

CLIENT
PRECISION IT GROUP

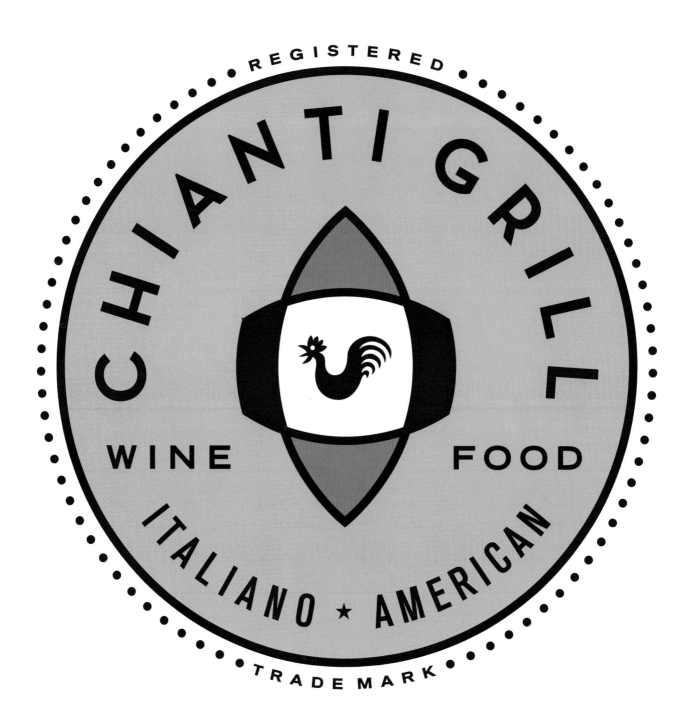

DESIGN CO.
COLLE + MCVOY

ART DIRECTOR
ED BENNETT

DESIGNER
RYAN CARLSON

CLIENT
CHIANTI GRILL

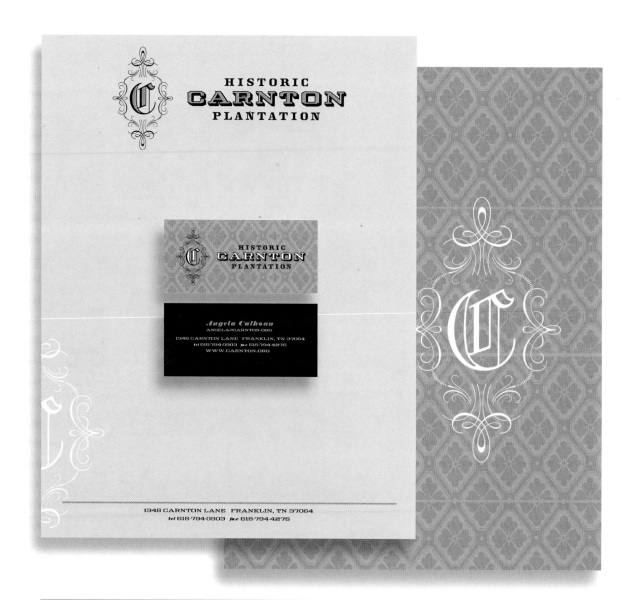

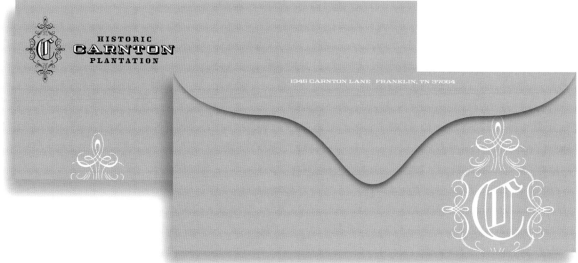

DESIGN CO.
LEWIS COMMUNICATIONS

DESIGNER
CLARK HOOK

CLIENT
CARTON PLANTATION

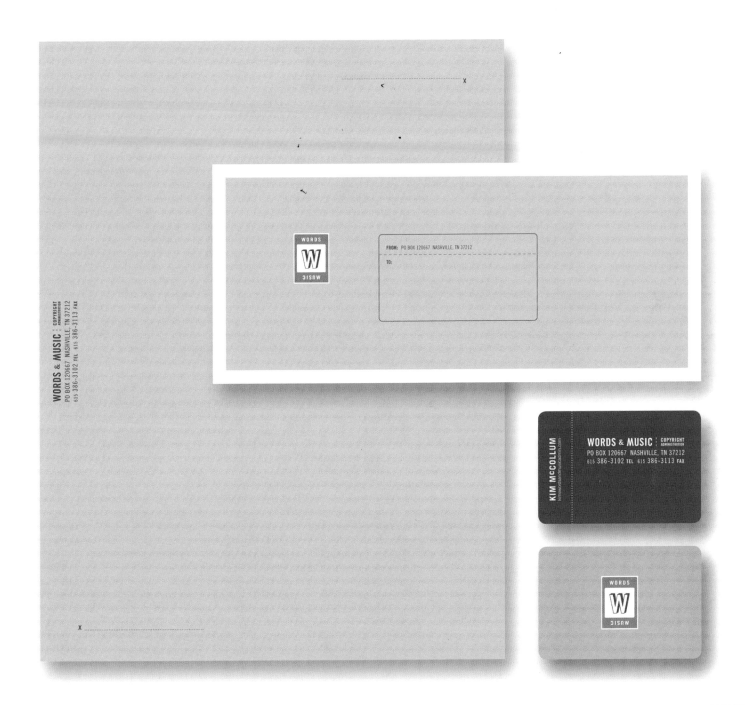

DESIGN CO.
LEWIS COMMUNICATIONS

DESIGNER
CLARK HOOK

CLIENT
WORDS AND MUSIC

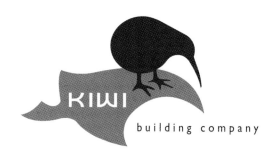

1

DESIGN CO.
SPARK COMMUNICATIONS

ART DIRECTOR
SHERRI LAWTON

DESIGNER
SHERRI LAWTON

CLIENT
KIWI BUILDING COMPANY

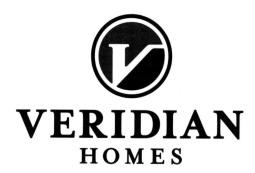

2

DESIGN CO.
SHINE ADVERTISING CO.

ART DIRECTOR
MIKE KRIEFSKI

DESIGNER
CHAD BOLLENBACH

CLIENT
VERIDIAN HOMES

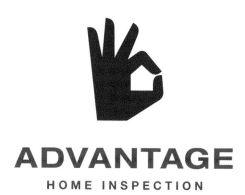

3

DESIGN CO.
LEWIS COMMUNICATIONS

ART DIRECTOR
ROBERT FROEDGE

CLIENT
ADVANTAGE

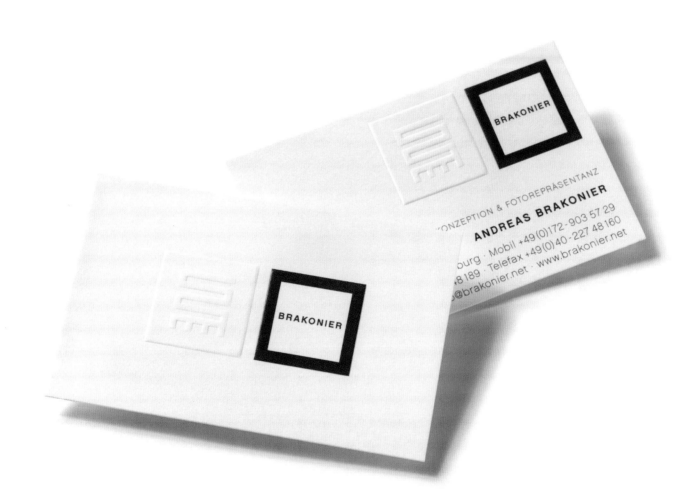

DESIGN CO.
MARIUS FAHRNER DESIGN

ART DIRECTOR
MARIUS FAHRNER

DESIGNER
MARIUS FAHRNER

CLIENT
ANDREAS BRAKONIER

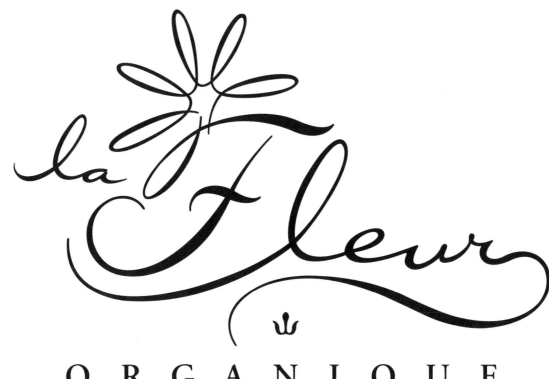

DESIGN CO.
ARCHRIVAL

ART DIRECTOR
CHARLES HULL

DESIGNER
JOEL KREUTZER

CLIENT
LA FLEUR ORGANIQUE

DESIGN CO.
THE PINK PEAR DESIGN COMPANY

ART DIRECTOR
SARAH SMITKA

DESIGNER
SARAH SMITKA

CLIENT
THE JUNIOR LEAGUE OF INDEPENDENCE

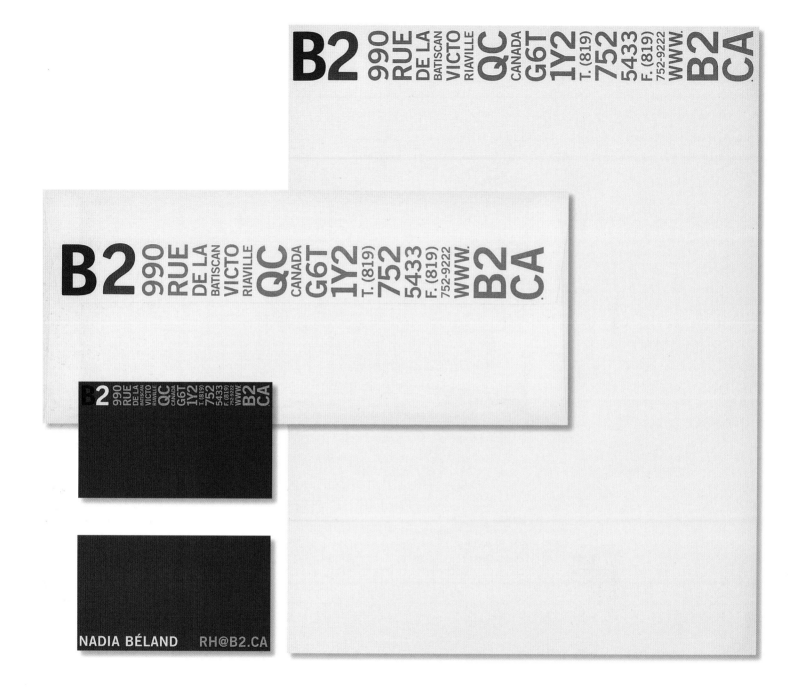

DESIGN CO.
PAPRIKA

ART DIRECTOR
LOUIS GAGNON

DESIGNER
RENE CLEMENT

CLIENT
BARONET

DESIGN CO.
PAPRIKA

ART DIRECTOR
LOUIS GAGNON

DESIGNER
RICHARD BELANGER

CLIENT
PAPRIKA

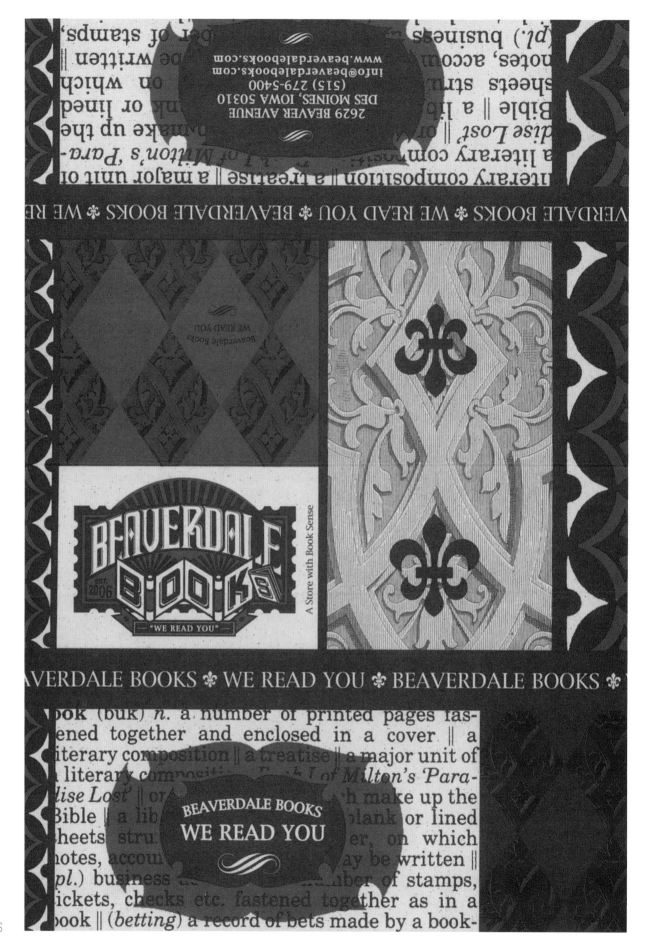

DESIGN CO.
SAYLES GRAPHIC DESIGN

ART DIRECTOR
JOHN SAYLES

DESIGNER
JESSI O'BRIEN & JOHN SAYLES

CLIENT
BEAVERDALE BOOKS

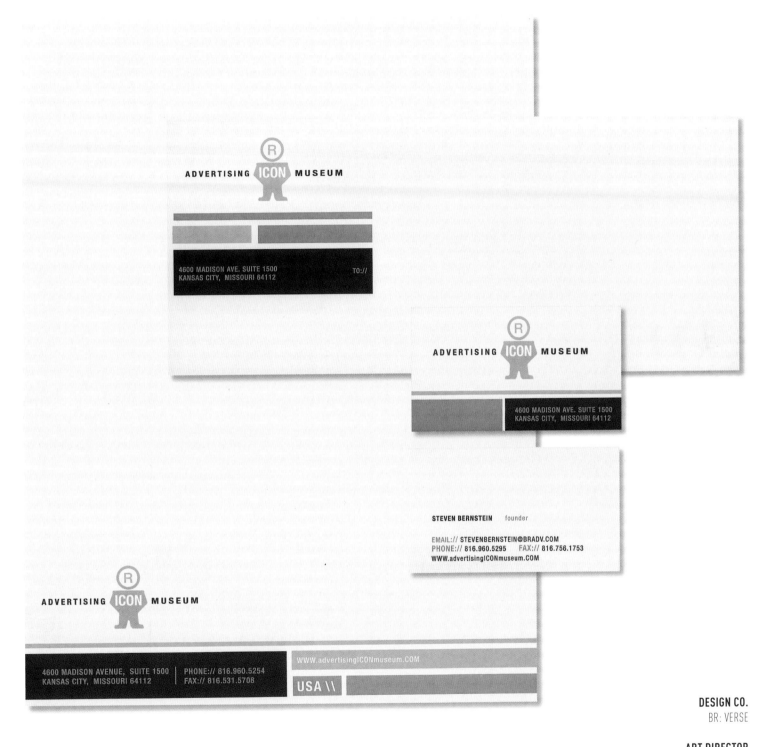

DESIGN CO.
BR: VERSE

ART DIRECTOR
NATHANIEL COOPER

DESIGNER
NATHANIEL COOPER

CLIENT
ADVERTISING ICON MUSEUM

612 W. Main Street
Madison, WI 53703

SHINE ADVERTISING CO., LI
P› 608 442 7373
F› 608 442 7374

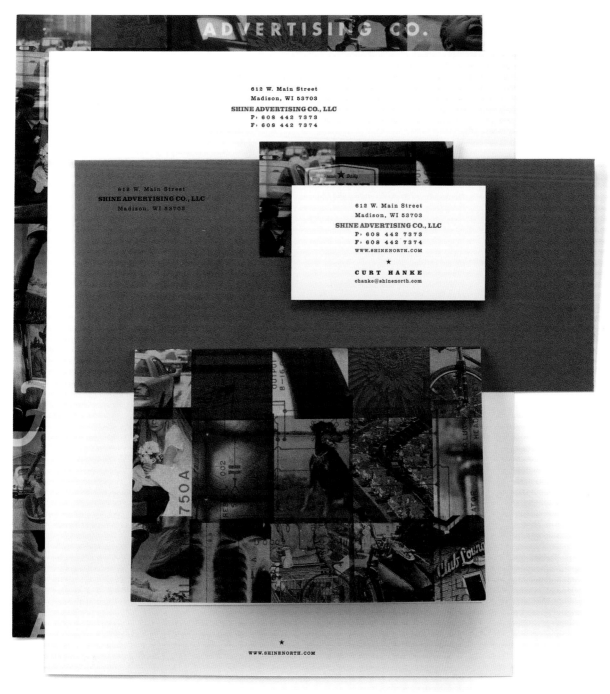

1

DESIGN CO.
PERISCOPE

ART DIRECTOR
JESSE BODELL

DESIGNER
JESSE BODELL

CLIENT
BUCA DI BEPPO

BAYSIDE MARKET logo

2

DESIGN CO.
MIRIELLO GRAFICO

DESIGNER
DENNIS GARCIA

CLIENT
BONEY'S BAYSIDE MARKET

INTERSTATE
· PREMIUM FOODS ·

DESIGN CO.
INDUSTRIO

ART DIRECTOR
ALLAN PETERS

DESIGNER
ALLAN PETERS

CLIENT
INTERSTATE PREMIUM FOODS

3

1

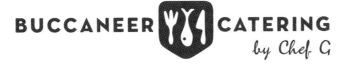

2

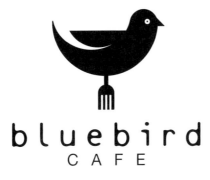

3

DESIGN CO.
HARTFORD DESIGN

ART DIRECTOR
TIM HARTFORD

DESIGNER
RON ALIKPALA

CLIENT
WHITE APRON

DESIGN CO.
PARACHUTE DESIGN

ART DIRECTOR
BOB UPTON

DESIGNER
CHARLIE ROSS

CLIENT
BUCCANEER CATERING + CHEF G

DESIGN CO.
DESIGN RANCH

ART DIRECTOR
INGRED SIDIE & MICHELLE SONDEREGGER

DESIGNER
INGRED SIDIE & MICHELLE SONDEREGGER

CLIENT
BLUE BIRD CAFE

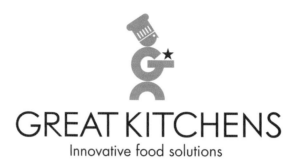

1

DESIGN CO.
HARTFORD DESIGN

ART DIRECTOR
TIM HARTFORD

DESIGNER
SCOTT HIGHT

CLIENT
GREAT KITCHENS

DESIGN CO.
TOKY BRANDING + DESIGN

ART DIRECTOR
ERIC THOELKE

DESIGNER
KATY FISCHER & ELVIS SWIFT

CLIENT
BUTLER'S PANTRY

2

THE CHOICE OF KINGS AND CONNOISSEURS

Bissinger's®

Handcrafted Chocolatier

1

Chopin

POTATO VODKA

2

DESIGN CO.
TOKY BRANDING + DESIGN

ART DIRECTOR
ERIC THOELKE

DESIGNER
JAMIE BANKS-GEORGE & GEOFF STORY

CLIENT
BISSINGER'S

DESIGN CO.
PARACHUTE DESIGN

ART DIRECTOR
BOB UPTON

DESIGNER
BOB UPTON

CLIENT
MOET HENNESSEY

JULIE A. MURRAY
chief executive officer
jmurray@threesquare.org

☎ 702 644·FOOD
📠 702 552·6574

💻 www.threesquare.org

✉ 8635 W. Sahara Ave. #240
Las Vegas, NV 89117

DESIGN CO.
CDI STUDIOS

ART DIRECTOR
BRIAN FELGAR & VICTORIA HART

DESIGNER
TRACY CASSTEVENS

CLIENT
THREE SQUARE

1

2

DESIGN CO.
SAYLES GRAPHIC DESIGN

ART DIRECTOR
JOHN SAYLES

DESIGNER
JESSI O'BRIEN & JOHN SAYLES

CLIENT
CAMPBELL'S NUTRITION

DESIGN CO.
HARTFORD DESIGN

ART DIRECTOR
TIM HARTFORD

DESIGNER
TIM HARTFORD

CLIENT
FLAT EARTH

DESIGN CO.
GRAPHICULTURE

ART DIRECTOR
CHERYL WATSON

DESIGNER
DANIEL ANDERSON, LINDSEY GICE, & CHAD OLSON

CLIENT
MINNESOTA CENTER FOR PHOTOGRAPHY

1

2

DESIGN CO.
EIGHTHOURDAY

ART DIRECTOR
KATIE KIRK & NATHAN STRANDBERG

DESIGNER
KATIE KIRK & NATHAN STRANDBERG

CLIENT
CORTEZ BROTHERS

DESIGN CO.
MINT DESIGN INC.

ART DIRECTOR
MIKE CALKINS & RYAN JACOBS

DESIGNER
MIKE CALKINS & RYAN JACOBS

CLIENT
POLITE SOCIETY

DESIGN CO.
RAMP

ART DIRECTOR
RACHEL ELNAR & MICHAEL STISNON

DESIGNER
MICHAEL STISNON

CLIENT
RAMP

OPEN GARDEN

DESIGN CO.
IMAGEHAUS

ART DIRECTOR
JAY MILLER

DESIGNER
JAMIE PAUL

CLIENT
OPEN GARDEN

THE SMOKEHOUSE
MARKET

SINCE
1937 FOODS & WINES INSPIRED BY THE RICHNESS OF COUNTRY LIFE.

16806 CHESTERFIELD AIRPORT ROAD CHESTERFIELD, MO 63005 TEL 636/532.3314 FAX 636/532.0561

SINCE

DESIGN CO.
TOKY BRANDING + DESIGN

ART DIRECTOR
ERIC THOELKE

DESIGNER
JAMIE BANKS-GEORGE

CLIENT
THE SMOKEHOUSE MARKET

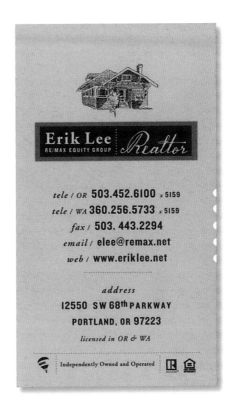

DESIGN CO.
SOCKEYE CREATIVE

ART DIRECTOR
PETER METZ

DESIGNER
KURT HOLLOMON

CLIENT
ERIK LEE REALTOR

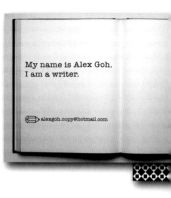

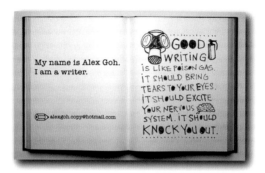

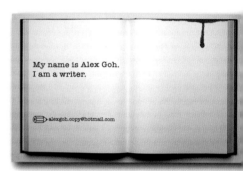

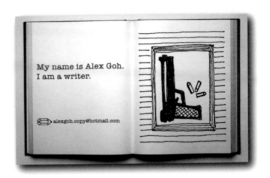

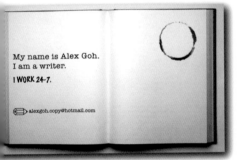

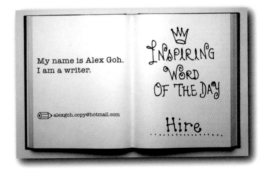

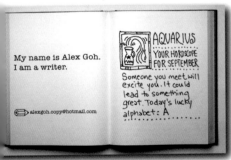

DESIGN CO.
KINETIC

ART DIRECTOR
PANN LIM & ROY POH

DESIGNER
ROY POH

CLIENT
ALEX GOH

DESIGN CO.
PARACHUTE DESIGN

ART DIRECTOR
BOB UPTON

DESIGNER
CHARLIE ROSS

CLIENT
HEATHER RADKE

DESIGN CO.
PARACHUTE DESIGN

ART DIRECTOR
BOB UPTON

DESIGNER
CHARLIE ROSS

CLIENT
HEATHER RADKE

1

DESIGN CO.
CAMPBELL FISHER

ART DIRECTOR
GREG FISHER

DESIGNER
STACY CRAWFORD & GREG FISHER

CLIENT
ARIZONA DIAMONDBACKS

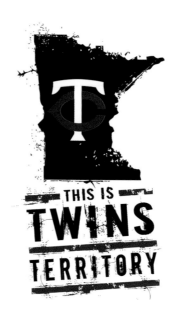

DESIGN CO.
PERISCOPE

ART DIRECTOR
JESSE BODELL

DESIGNER
JESSE BODELL

CLIENT
MINNESOTA TWINS

2

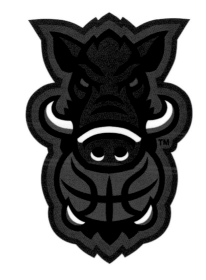

1

2

DESIGN CO.
RICKABAUGH GRAPHICS

ART DIRECTOR
ERIC RICKABAUGH

DESIGNER
DAVE CAP

CLIENT
BALL HAWG

DESIGN CO.
RICKABAUGH GRAPHICS

ART DIRECTOR
ERIC RICKABAUGH

DESIGNER
DAVE CAP

CLIENT
LOUISIANA MONROE

BEN WEE
DIRECTOR

EMAIL : benweez2@gmail.com
MOBILE : +62 811 194392
WEBSITE : filmworkscollective.com

ACTION!
Opens in a meeting room full of people.
Camera at 50 frames per second.
Hero stands up. He reaches into his
pocket, pulls out a bunch of cards and
distributes. Everyone looks so impressed.
CUT!

ACTION!
Close up shot of hands exchanging
cards. Cut to wide-angle head shot
of female talent. She smiles, puts the
card into her hangbag and says:
"I'll call you soon". Defocus.
CUT!

ACTION!
Shot of a nondescript restaurant.
Cut to handheld shot of hero sliding
something across the table towards talent.
Talent looks around, before picking it
up to reveal a card. Talent reads the
card and answers: "We'll be in touch".
CUT!

DESIGN CO.
KINETIC

ART DIRECTOR
PANN LIM & ROY POH

DESIGNER
ROY POH & JONATHAN YUEN

CLIENT
BEN WEE

1

DESIGN CO.
BURTON CORPORATION

DESIGNER
TOBY GRUBB

CLIENT
BURTON SNOWBOARDS

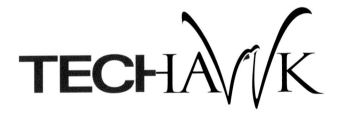

2

DESIGN CO.
KOTA DESIGN

ART DIRECTOR
STEPHEN HALL

DESIGNER
RON J. PRIDE

CLIENT
TECHAWK

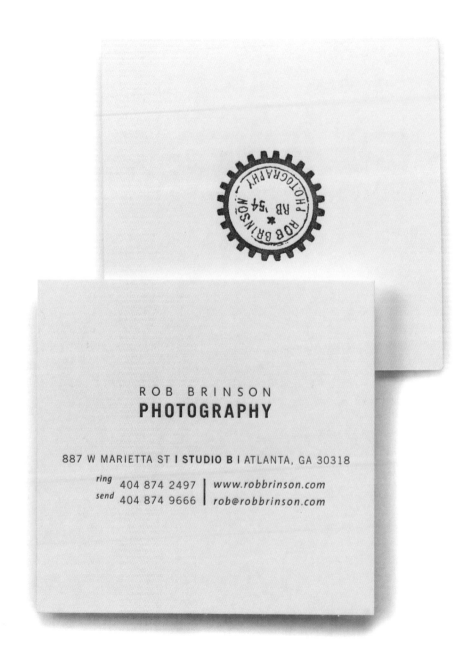

DESIGN CO.
PRINCIPLE, INC.

ART DIRECTOR
PAMELA ZUCCKER

DESIGNER
PAMELA ZUCCKER

CLIENT
ROB BRINSON PHOTOGRAPHY

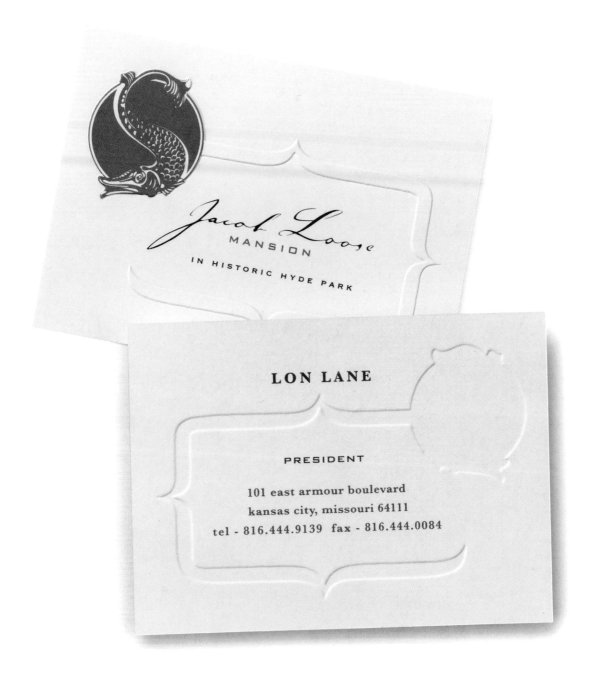

Jacob Loose
MANSION
IN HISTORIC HYDE PARK

LON LANE

PRESIDENT

101 east armour boulevard
kansas city, missouri 64111
tel - 816.444.9139 fax - 816.444.0084

DESIGN CO.
BR: VERSE

ART DIRECTOR
NATHANIEL COOPER

DESIGNER
NATHANIEL COOPER

CLIENT
HARRIMAN-JEWELL SERIES

DESIGN ARMY

1312 9TH ST NW SUITE 200
WASHINGTON, D.C. 20001
202 797 1018 TELEPHONE
202 478 1807 FACSIMILE
PUM@DESIGNARMY.COM

PUM LEFEBURE

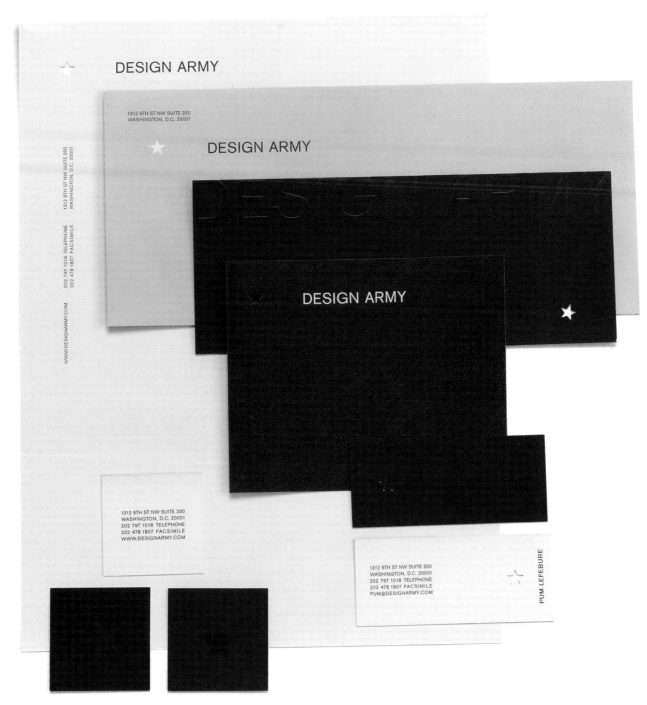

DESIGN CO.
DESIGN ARMY

ART DIRECTOR
JAKE LEFEBURE & PUM LEFEBURE

DESIGNER
DAN ADLER

CLIENT
DESIGN ARMY

1

DESIGN CO.
RYAN COOPER DESIGN

ART DIRECTOR
RYAN COOPER

DESIGNER
RYAN COOPER

CLIENT
DAVE HALL/HALL NETWORKING

DESIGN CO.
RYAN COOPER DESIGN

ART DIRECTOR
RYAN COOPER

DESIGNER
RYAN COOPER

2

CLIENT
THOMAS COTTLE/A PLUS MOVING AND STORAGE

C L O U D T H E O R Y

1

2

DESIGN CO.
CLOUDTHEORY

ART DIRECTOR
JENNIFER WON

DESIGNER
JENNIFER WON

CLIENT
CLOUDTHEORY

DESIGN CO.
PARACHUTE DESIGN

ART DIRECTOR
BOB UPTON

DESIGNER
CHARLIE ROSS

CLIENT
JULIE RUDDY

1

DESIGNER
RYAN CARLSON

CLIENT
BAREFOOT BREWERY

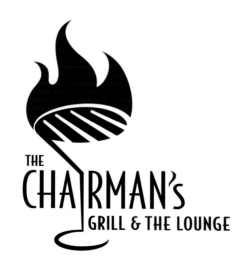

DESIGN CO.
FUSZION

ART DIRECTOR
RICK HEFFNER

DESIGNER
KHOI TRAN

CLIENT
MADISON HOTELS

2

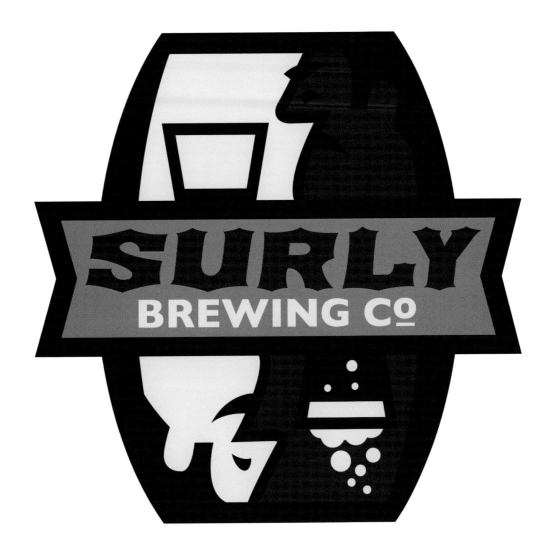

DESIGN CO.
BIDWELL ID

ART DIRECTOR
JOHN BIDWELL

DESIGNER
TODD VERLANDER

CLIENT
SURLY BREWING CO.

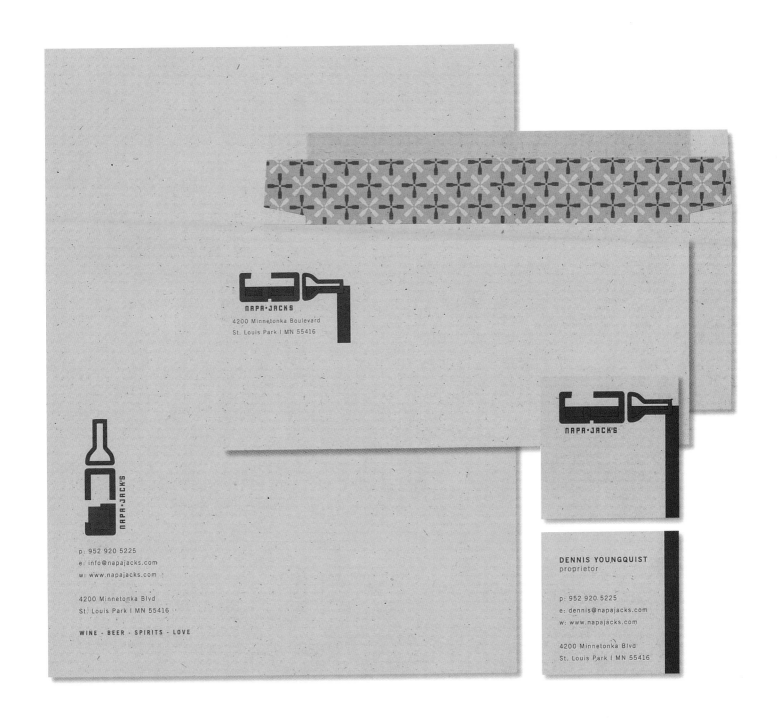

DESIGN CO.
IMAGEHAUS

ART DIRECTOR
JAY MILLER

DESIGNER
JAMIE PAUL

CLIENT
NAPA JACK'S

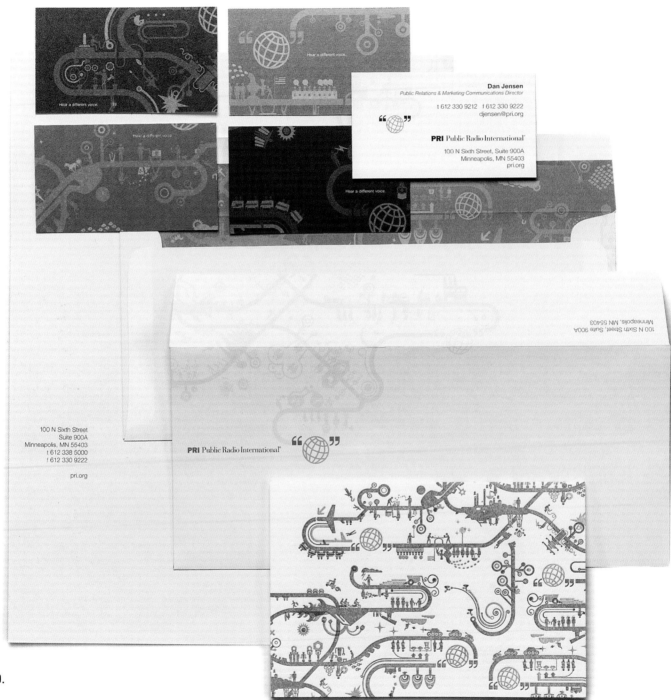

DESIGN CO.
MONO

DESIGNER
TRAVIS OLSON

CLIENT
PUBLIC RADIO INTERNATIONAL

DESIGN CO.
BURTON CORPORATION

ART DIRECTOR
ALEX LOWE

DESIGNER
SI SCOTT

CLIENT
BURTON SNOWBOARDS

1

DESIGNER
RYAN CARLSON & BRENT GALE

CLIENT
TWIN SIX

DESIGN CO.
COLLE + MCVOY

ART DIRECTOR
ED BENNETT & MIKE FETROW

DESIGNER
RYAN CARLSON

CLIENT
LITTLE TRANSPORT PRESS

2

1

2

DESIGN CO.
INITIO

ART DIRECTOR
JOE MONNENS

DESIGNER
ALEX DUBROVSKY, JOE MONNENS, & RANDY PIERCE

CLIENT
THE TRIKE SHOP

DESIGN CO.
MONO

DESIGNER
TRAVIS OLSON

CLIENT
CUSTOM CHROME

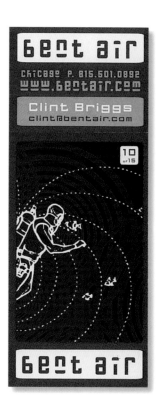

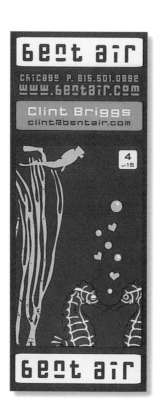

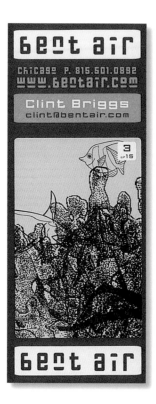

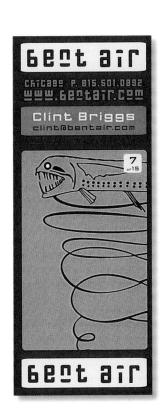

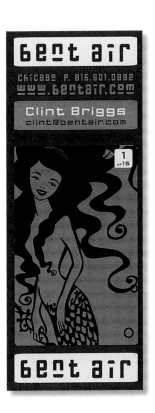

DESIGN CO.
CATALYST STUDIOS

ART DIRECTOR
JASON RYSAVI

DESIGNER
JENNIFER O'BRIEN

CLIENT
BENT AIR

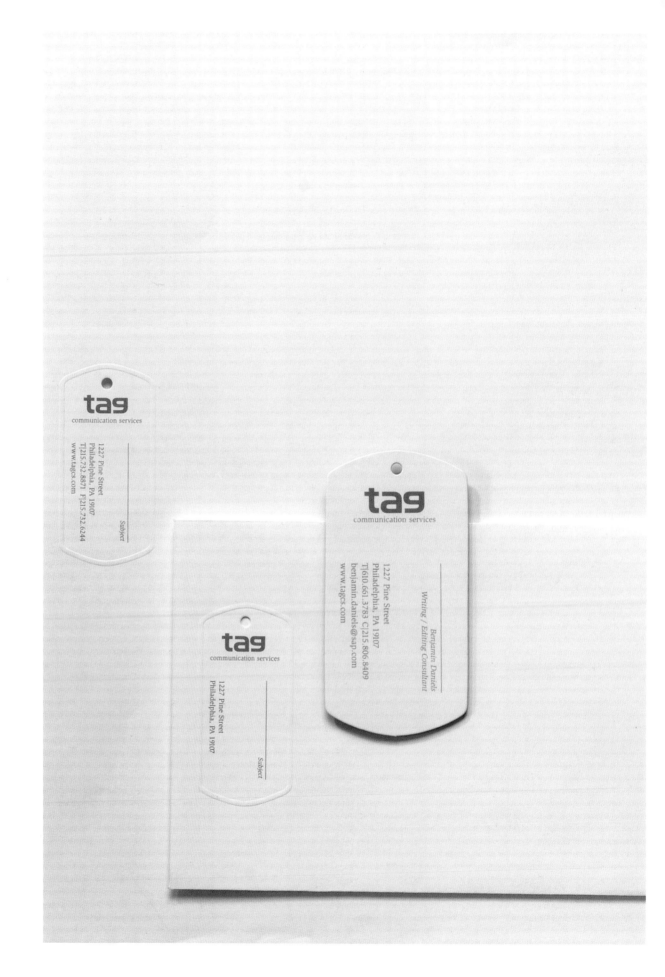

DESIGN CO.
JOHNSTON DUFFY

ART DIRECTOR
MARTIN DUFFY

DESIGNER
CHRISTINE JOHNSTON

CLIENT
TAG COMMUNICATIONS SERVICES

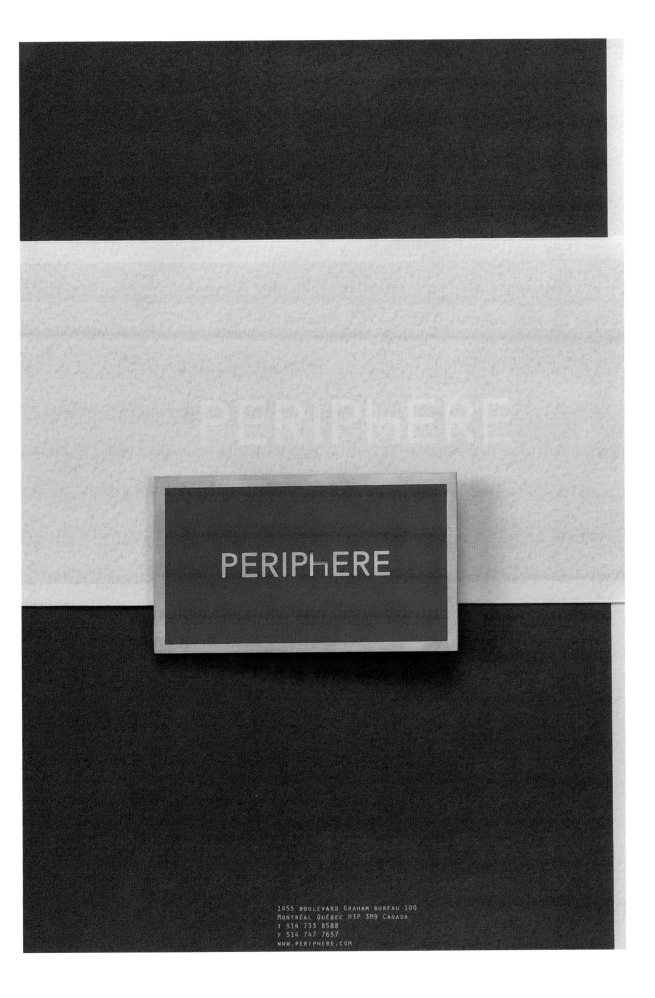

1455 BOULEVARD GRAHAM BUREAU 100
MONTRÉAL QUÉBEC H3P 3M9 CANADA
T 514 733 8588
F 514 747 7657
WWW.PERIPHERE.COM

DESIGN CO.
PAPRIKA

ART DIRECTOR
LOUIS GAGNON

DESIGNER
ISABELLE D'ASTOUS

CLIENT
PERIPHERE

UNLEASHED

UNLEASHED

UNLEASHED

UNLEASHED

UNLEASHED

UNLEASHED

UNLEASHED

UNLEASHED

DESIGN CO.
HARTUNG KEMP

ART DIRECTOR
STEFAN HARTUNG

DESIGNER
STEFAN HARTUNG & DAWN WENCK

CLIENT
SLEEPING DOG, LTD.

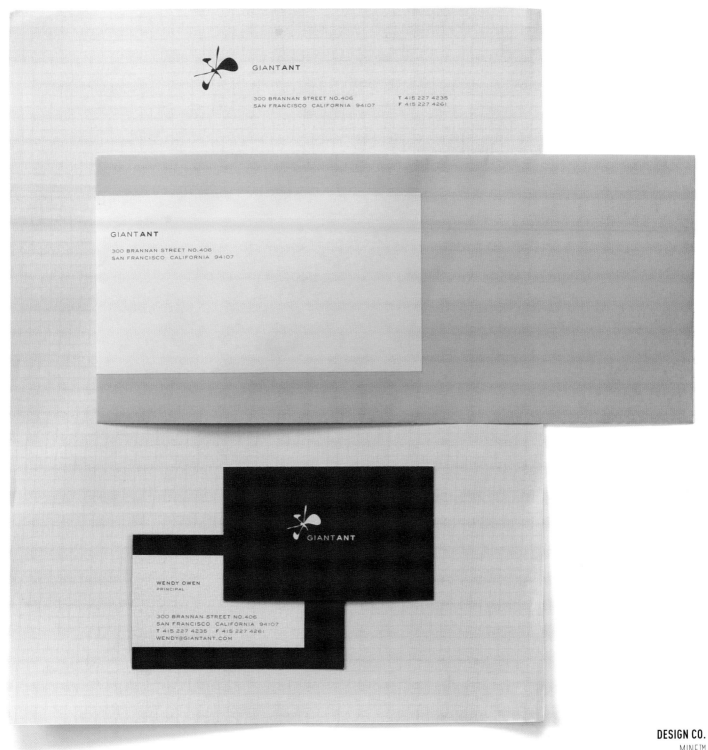

DESIGN CO.
MINE™

ART DIRECTOR
CHRISTOPHER SIMMONS

DESIGNER
NANCY HSIEH & CHRISTOPHER SIMMONS

CLIENT
GIANT ANT

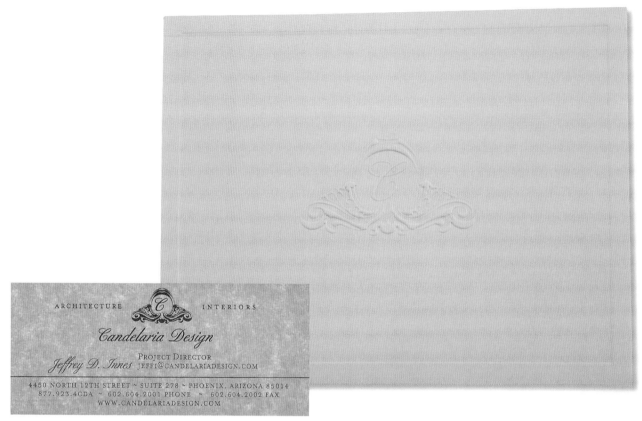

DESIGN CO.
TOMKO DESIGN

ART DIRECTOR
MIKE TOMKO

DESIGNER
MIKE TOMKO

CLIENT
CANDELARIA DESIGN

TELE **602 604 2001** FACS **602 604 2002**

MAILING **POST OFFICE BOX 7400** ~ **PHOENIX, ARIZONA 85011**
LOCATION **4114 NORTH TWENTY-EIGHTH STREET** ~ **PHOENIX, ARIZONA 85016**

WWW.ILCORTILE-AZ.COM

TELE FACS
602 604 2001 602 604 2002
WWW.ILCORTILE-AZ.COM

INFO@ILCORTILE-AZ.COM

MAILING
POST OFFICE BOX 7400
PHOENIX, ARIZONA 85011

LOCATION
4114 NORTH TWENTY-EIGHTH STREET
PHOENIX, ARIZONA 85016

DESIGN CO.
TOMKO DESIGN

ART DIRECTOR
MIKE TOMKO

DESIGNER
MIKE TOMKO

CLIENT
Il CORTILE

1

DESIGN CO.
CALAGRAPHIC DESIGN

ART DIRECTOR
RONALD J. CALA II

DESIGNER
RONALD J. CALA II

CLIENT
CALAGRAPHIC DESIGN

DESIGN CO.
FUSZION

DESIGNER
JOHN FOSTER

CLIENT
MCPS THOMAS S. WOOTTON HIGH SCHOOL

2

DESIGN CO.
ARCHRIVAL

DESIGNER
JOEL KREUTZER

CLIENT
JIM ESCH FOR CONGRESS

1

DESIGN CO.
CARMICHAEL LYNCH THORBURN

ART DIRECTOR
MICHAEL SKJEI

DESIGNER
TRAVIS OLSON

CLIENT
NORTHWEST AIRLINES

DESIGN CO.
GRETEMAN GROUP

ART DIRECTOR
SONIA GRETEMAN

DESIGNER
CRAIG TOMSON

CLIENT
BOMBARDIER FLEXJET

2

ZODIACS

1

UGL™

2

DESIGN CO.
LEWIS COMMUNICATIONS

ART DIRECTOR
ROBERT FROEDGE

CLIENT
ZODIACS

DESIGN CO.
DENIZ MARLALI

ART DIRECTOR
DENIZ MARLALI

DESIGNER
DENIZ MARLALI

CLIENT
UNIVERSAL GEMOLOGICAL LABS

PHILIPPE
ARCHONTAKIS
.COM

PHILIPPE
ARCHONTAKIS
.COM

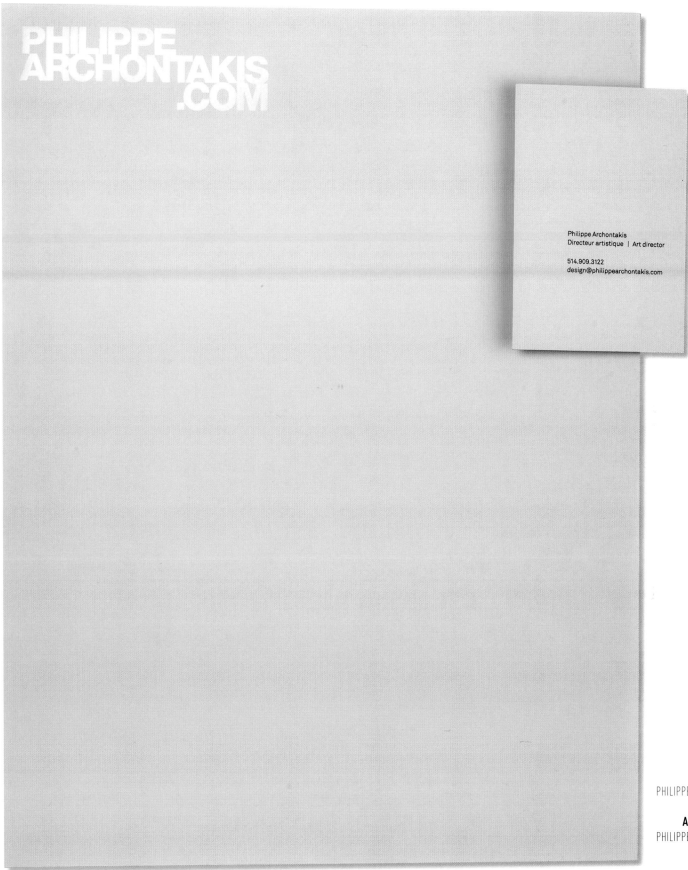

PHILIPPE
ARCHONTAKIS
.COM

Philippe Archontakis
Directeur artistique | Art director

514.909.3122
design@philippearchontakis.com

DESIGN CO.
PHILIPPE ARCHONTAKIS

ART DIRECTOR
PHILIPPE ARCHONTAKIS

DESIGNER
PHILIPPE ARCHONTAKIS

CLIENT
PHILIPPE ARCHONTAKIS

1

DESIGN CO.
BAMBOO

ART DIRECTOR
KATHY SORANNO

DESIGNER
JAMIE STEARNS

CLIENT
D'AMICO & PARTNERS

2

DESIGN CO.
PARACHUTE DESIGN

ART DIRECTOR
BOB UPTON

DESIGNER
CHARLIE ROSS

CLIENT
LUXURY RESIDENCE COLLECTION

DESIGN CO.
GRETEMAN GROUP

ART DIRECTOR
SONIA GRETEMAN

DESIGNER
CHRIS PARKS

CLIENT
CITY OF WICHITA

3

1

2

3

DESIGN CO.
RICKABAUGH GRAPHICS

ART DIRECTOR
ERIC RICKABAUGH

DESIGNER
ERIC RICKABAUGH

CLIENT
OKLAHOMA STATE UNIVERSITY PGS

DESIGN CO.
GRAPHICULTURE

ART DIRECTOR
CHERYL WATSON

DESIGNER
LINDSEY GICE

CLIENT
TALLY-HO SUPPER CLUB

DESIGN CO.
WESTMORELANDFLINT

ART DIRECTOR
KEN ZAKOVICH

DESIGNER
KEN ZAKOVICH

CLIENT
BARKHOUSE BISTRO

DESIGN CO.
BURTON CORPORATION

ART DIRECTOR
DAN RONNER-BLAND

1

DESIGNER
TOBY GRUBB

CLIENT
BURTON SNOWBOARDS

DESIGN CO.
SYNERGY GRAPHICS

ART DIRECTOR
REMO STRADA

CLIENT
WHALE COMMUNICATIONS

2

DESIGN CO.
SYNERGY GRAPHICS

ART DIRECTOR
REMO STRADA

CLIENT
PIRANHA EXTREME SPORTS

3

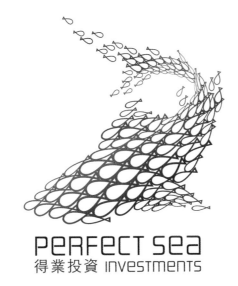

1

DESIGN CO.
DEMIURGE UNIT LIMITED

ART DIRECTOR
TEDDY LO

DESIGNER
RICKY LO

CLIENT
PERFECT SEA INVESTMENTS LIMITED

2

DESIGN CO.
RUBIN CORDARO DESIGN

ART DIRECTOR
BRUCE RUBIN

DESIGNER
JIM CORDARO

CLIENT
TOWER LOFTS

3

DESIGN CO.
RUBIN CORDARO DESIGN

ART DIRECTOR
BRUCE RUBIN

DESIGNER
JIM CORDARO

CLIENT
BELLA ON THE BAY

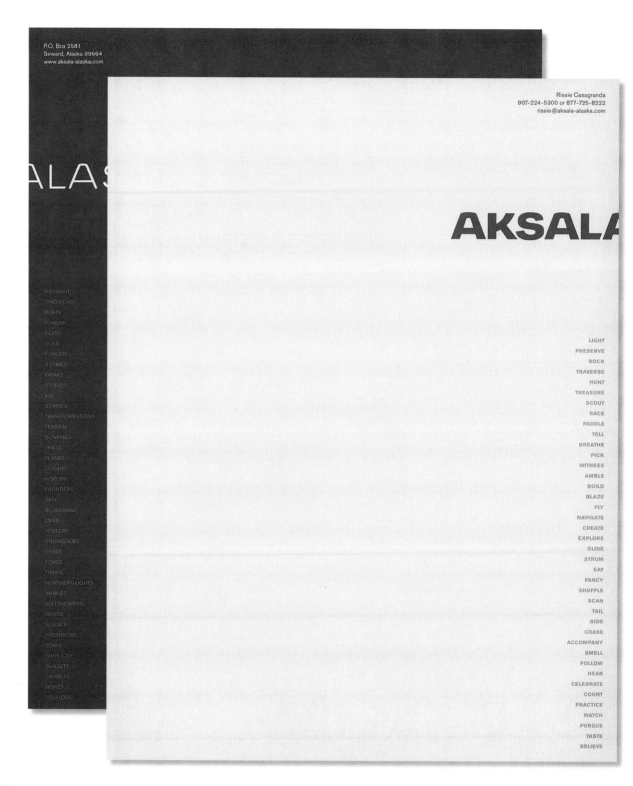

DESIGN CO.
DANIEL P. JOHNSTON/ANNA SIMUTIS

DESIGNER
DANIEL P. JOHNSTON/ANNA SIMUTIS

CLIENT
AKSALA-ALASKA

DESIGN CO.
PARACHUTE DESIGN

ART DIRECTOR
BOB UPTON

DESIGNER
SEAN LIEN

CLIENT
RMF GROUP

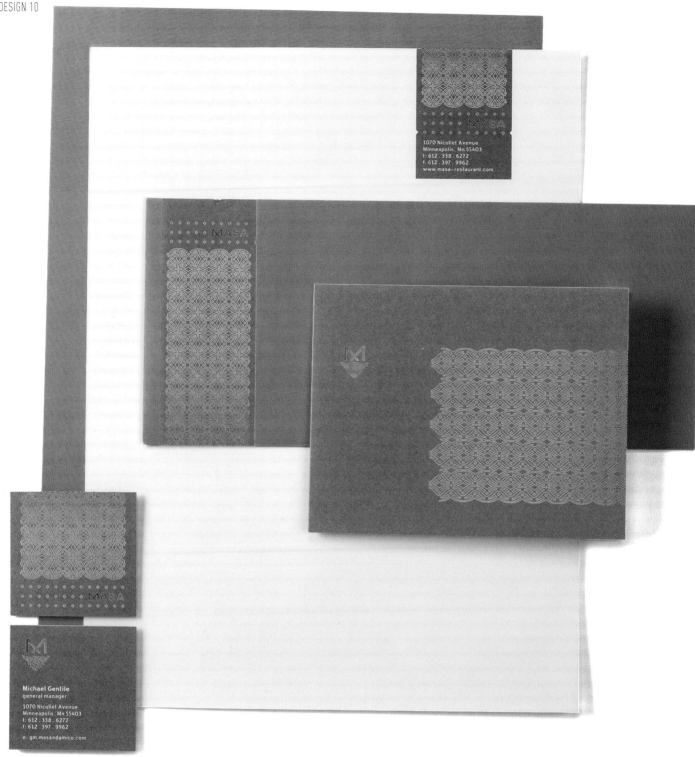

DESIGN CO.
BAMBOO

ART DIRECTOR
KATHY SORANNO

DESIGNER
KATHY SORANNO

CLIENT
DAMICO J PARTNERS

DESIGN CO.
MIRIELLO GRAFICO

DESIGNER
DENNIS GARCIA

CLIENT
THE WALT DISNEY COMPANY

EDUCATION TO CHANGE LIVES

1

DESIGN CO.
GEE + CHUNG DESIGN

ART DIRECTOR
EARL GEE

DESIGNER
EARL GEE

CLIENT
GIVE SOMETHING BACK INTERNATIONAL

DESIGN CO.
FUSZION

DESIGNER
CHRISTIAN BALDO

CLIENT
READING IS FUNDAMENTAL

2

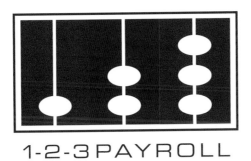

1-2-3 PAYROLL

1

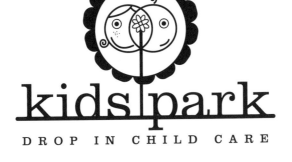

kids park

DROP IN CHILD CARE

2

DESIGN CO.
GULLA DESIGN

ART DIRECTOR
STEVE GULLA & PAM DAVIES

DESIGNER
STEVE GULLA

CLIENT
1-2-3 PAYROLL

DESIGN CO.
BLUE TRICYCLE

ART DIRECTOR
KEITH GRIFFIN

DESIGNER
HEATHER GRIFFIN

CLIENT
KIDS PARK

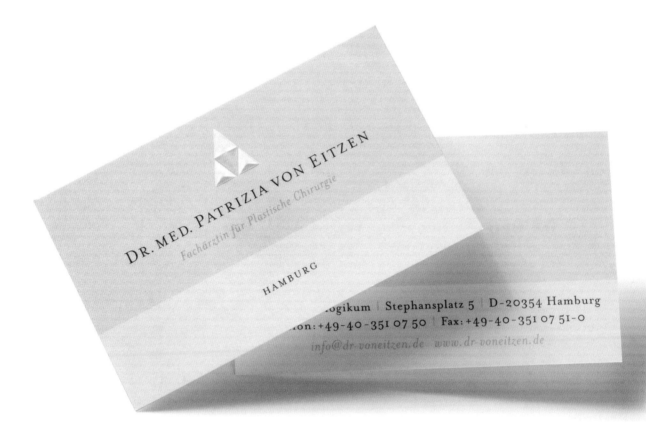

DR. MED. PATRIZIA VON EITZEN

Fachärztin für Plastische Chirurgie

HAMBURG

...ogikum | Stephansplatz 5 | D-20354 Hamburg
...on: +49-40-351 07 50 | Fax: +49-40-351 07 51-0

info@dr-voneitzen.de www.dr-voneitzen.de

DESIGN CO.
MARIUS FAHRNER DESIGN

ART DIRECTOR
MARIUS FAHRNER

DESIGNER
ALINE REUTER

CLIENT
DR. VON EITZEN

MALCOLM M. LLOYD, MD

OLD NASSAU
••• IMPORTS •••

MLLOYD@OLDNASSAUIMPORTS.COM

ON...
PRINCET...

DEVIN WILSON

OLD NASSAU
••• IMPORTS •••

DWILSON@OLDNASSAUIMPORTS.COM

ONE COTSWALD LANE
PRINCETON, NEW JERSEY 08540

tel 617.909.3770
fax 609.333.0882

DESIGN CO.
CAPSULE

ART DIRECTOR
BRIAN ADDUCCI

DESIGNER
BRIAN ADDUCCI

CLIENT
OLD NASSAU IMPORTS

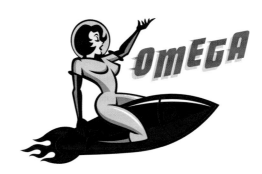

1

DESIGN CO.
MINE™

ART DIRECTOR
CHRISTOPHER SIMMONS

DESIGNER
TIM BELONAX & CHRIS PARKS

CLIENT
OMEGA HIGH POWER ROCKETRY

2

DESIGN CO.
SEGURA INC.

PANTEASE™

DESIGN CO.
DESIGN RANCH

ART DIRECTOR
INGRED SIDIE & MICHELLE SONDEREGGER

DESIGNER
MICHELLE SONDEREGGER

CLIENT
PANTEASE

3

DESIGN CO.
TRUE NORTH

ART DIRECTOR
ADY BIBBY

DESIGNER
STU PRICE

CLIENT
DANNY MYCOCK

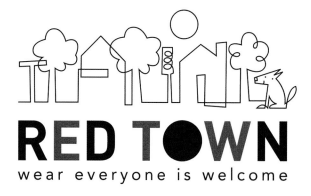

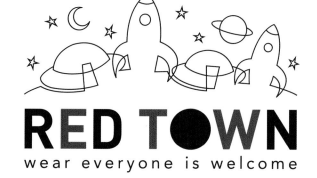

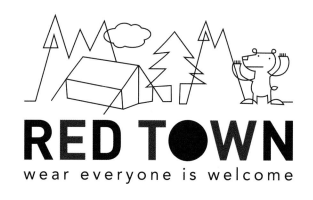

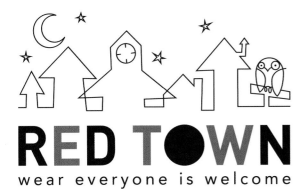

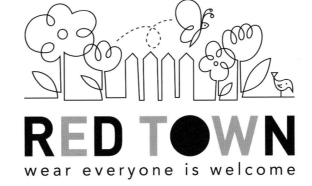

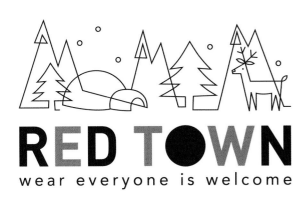

DESIGN CO.
DESIGN RANCH

ART DIRECTOR
INGRED SIDIE & MICHELLE SONDEREGGER

DESIGNER
TAD CARPENTER & MICHELLE SONDEREGGER

CLIENT
TARGET

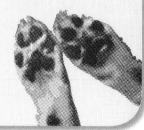

Jean Peters
Owner

113A Bell Street
Down The Alley
Seattle, WA 98121

P 206.374.WAGS

DOGGIE CARE
DOGGIE EVERYTHING

wagsofbelltown.com

113A Bell Street
Down The Alley
Seattle, WA 98121

P 206.374.WAGS
wagsofbelltown.com

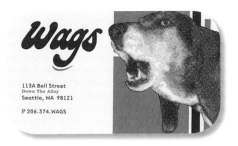

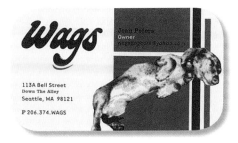

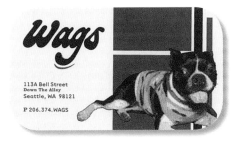

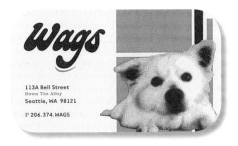

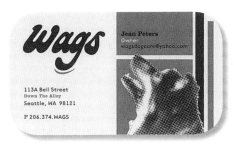

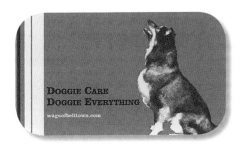

DESIGN CO.
URBANINFLUENCE DESIGN STUDIO

ART DIRECTOR
HENRY YIU

DESIGNER
MIKE MATES & HENRY YIU

CLIENT
WAGS

1

DESIGN CO.
INITIO

ART DIRECTOR
JOE MONNENS

DESIGNER
JOE MONNENS

CLIENT
OXYGENATOR WATER TECHNOLOGY

DESIGN CO.
CUE, INC.

ART DIRECTOR
ALAN COLVIN

DESIGNER
PAUL SIEKA

CLIENT
BRIGGS & STRATTON

2

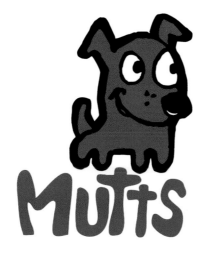

1

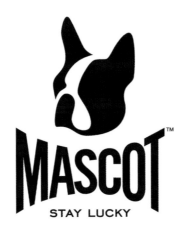

2

DESIGN CO.
MODERN DOG DESIGN CO.

ART DIRECTOR
ROBYNNE RAYE

DESIGNER
VITTORIO COSTARELLA

CLIENT
MUTTS

DESIGN CO.
BOB DINETZ DESIGN

ART DIRECTOR
BOB DINETZ

DESIGNER
BOB DINETZ

CLIENT
MASCOT

 Limb Design

7026 Old Katy Road, Suite 350
Houston, Texas 77024

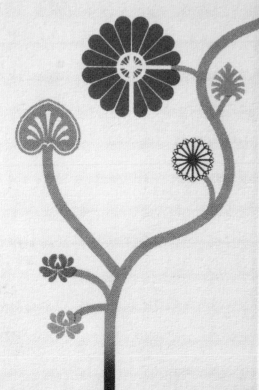

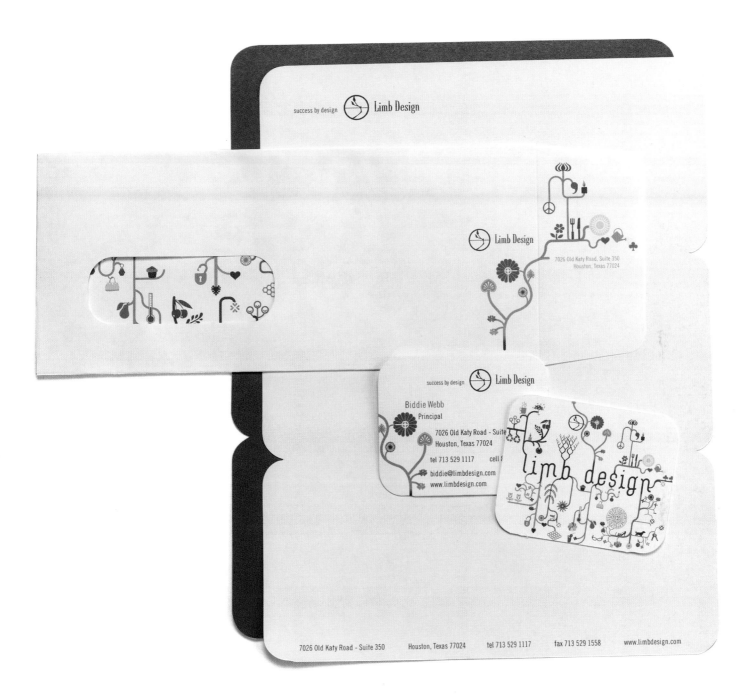

DESIGN CO.
LIMB DESIGN

ART DIRECTOR
ELISE DESILVA

DESIGNER
EMILIE GRUSON

CLIENT
BIDDIE WEBB

REACH HIGHER

1

DESIGN CO.
WESTMORELANDFLINT

ART DIRECTOR
KEN ZAKOVICH

DESIGNER
KEN ZAKOVICH

CLIENT
UNIVERSITY OF MINNESOTA-DULUTH

DESIGN CO.
HARTFORD DESIGN

ART DIRECTOR
TIM HARTFORD

DESIGNER
RON ALIKPALA

CLIENT
MEAD WESTVACO

2

1

2

DESIGN CO.
INITIO

ART DIRECTOR
JOE MONNENS

CLIENT
JOHN RADATZ

DESIGN CO.
GRETEMAN GROUP

ART DIRECTOR
SONIA GRETEMAN

DESIGNER
GARRETT FRESH

CLIENT
ROYAL CARIBBEAN

1

DESIGNER
RYAN CARLSON

CLIENT
NEW PRAGUE GOLF CLUB

DESIGN CO.
BURTON CORPORATION

DESIGNER
TOBY GRUBB

CLIENT
BURTON SNOWBOARDS

2

1

2

DESIGN CO.
RICKABAUGH GRAPHICS

ART DIRECTOR
ERIC RICKABAUGH

DESIGNER
DAVE CAP

CLIENT
LOUISIANA MONROE

DESIGN CO.
COLLE + MCVOY

ART DIRECTOR
ED BENNETT & MIKE FETROW

DESIGNER
RYAN CARLSON

CLIENT
COLLE + MCVOY

1

DESIGN CO.
MINT DESIGN INC.

ART DIRECTOR
MIKE CALKINS & RYAN JACOBS

DESIGNER
MIKE CALKINS

CLIENT
BLUE JAY PRODUCTIONS

DESIGN CO.
BR: VERSE

ART DIRECTOR
FRANKLIN OVIEDO

DESIGNER
FRANKLIN OVIEDO

CLIENT
CAMP PORTFOLIO

2

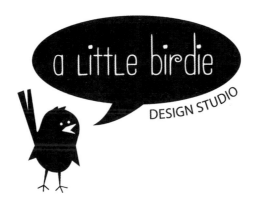

1

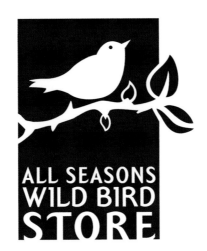

2

DESIGN CO.
A LITTLE BIRDIE DESIGN STUDIO

ART DIRECTOR
MELISSA HORTON

DESIGNER
MELISSA HORTON

CLIENT
A LITTLE BIRDIE DESIGN STUDIO

DESIGN CO.
IMAGEHAUS

ART DIRECTOR
JAY MILLER

DESIGNER
COLLEEN MEYER

CLIENT
ALL SEASONS WILD BIRD STORE

1

DESIGN CO.
DOTZERO DESIGN

DESIGNER
JON WIPPICH & KAREN WIPPICH

CLIENT
PERSIMMON DEVELOPMENT GROUP

DESIGN CO.
CARMICHAEL LYNCH THORBURN

ART DIRECTOR
BILL THORBURN

DESIGNER
JESSE KACZMREK & PATRICK MILLER

CLIENT
CITY OF MINNEAPOLIS

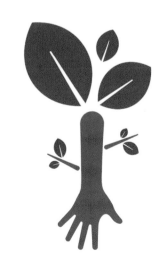

2

_garden_elements

1

NATURCote™

2

DESIGN CO.
INITIO

ART DIRECTOR
JOE MONNENS

DESIGNER
ADAM KING

CLIENT
MASTER NURSERY

DESIGN CO.
GO WELSH

ART DIRECTOR
CRAIG WELSH

DESIGNER
RYAN SMOKER

CLIENT
ARMSTRONG

DESIGN CO.
LOVELY

DESIGNER
KEVIN HAYES

CLIENT
LOVELY

1

2

DESIGN CO.
INITIO

ART DIRECTOR
JOE MONNENS

DESIGNER
JOE MONNENS

CLIENT
OVATION SCIENCE

DESIGN CO.
WESTMORELANDFLINT

ART DIRECTOR
KEN ZAKOVICH

DESIGNER
KEN ZAKOVICH

CLIENT
BOIS FORTE BAND OF CHIPPEWA

2010 East

MICHAEL BARTZ

B+W Specialty Coffee
2010 East Hennepin Ave #70 t 612.331.5345
Minneapolis, MN 55413 f 612.331.2914
t 800.331.2534 e mike@bwjava.com

1

DESIGN CO.
BAMBOO

ART DIRECTOR
KATHY SORANNO

DESIGNER
KATHY SORANNO

CLIENT
B&W SPECIALTY COFFEE

DESIGN CO.
BAMBOO

ART DIRECTOR
KATHY SORANNO

DESIGNER
KATHY SORANNO

CLIENT
B&W SPECIALTY COFFEE

SPECIALTY COFFEE

2

1

DESIGNER
ANNIE SULLIVAN

CLIENT
A CUP OF JOE

2

DESIGN CO.
BLUE TRICYCLE

ART DIRECTOR
KEITH GRIFFIN

DESIGNER
RONALD GRIFFIN

CLIENT
CONNECT CAFE

3

DESIGN CO.
A3 DESIGN

ART DIRECTOR
ALAN ALTMAN

DESIGNER
AMANDA ALTMAN

CLIENT
HOT SAKE

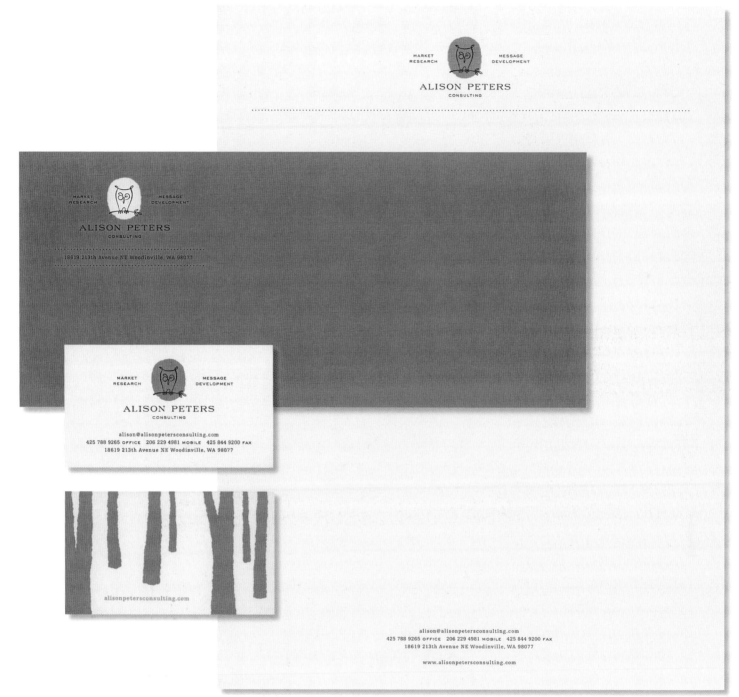

DESIGN CO.
PARTLY SUNNY

DESIGNER
PAT SNAVELY

CLIENT
ALISON PETERS CONSULTING

DESIGN CO.
DESIGN RANCH

ART DIRECTOR
INGRED SIDIE &
MICHELLE SONDEREGGER

DESIGNER
TAD CARPENTER & RACHEL KARACA

CLIENT
NARA

DESIGN CO.
INITIO

ART DIRECTOR
JOE MONNENS

DESIGNER
JOE MONNENS

CLIENT
JOE MONNENS

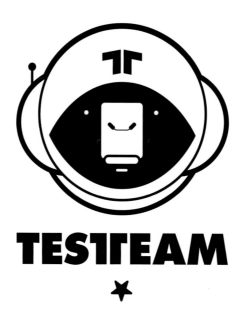

DESIGN CO.
BURTON CORPORATION

DESIGNER
TOBY GRUBB

CLIENT
BURTON SNOWBOARDS

OPEN INTELLIGENCE AGENCY
RUSSELL DAVIES
LONDON

+44 (0)7976 974 340
russell@openintelligenceagency.com

OPEN INTELLIGENCE AGENCY
DAVID NOTTOLI
NEW YORK

david@openintelligenceagency.com
+1 917 207 4387

Emily Reed

emily@openintelligenceagency.com
+61 4 1241 9644

OPEN INTELLIGENCE AGENCY

LONDON SYDNEY AMSTERDAM NEW YORK

OPEN INTELLIGENCE AGENCY
JEFFRE JACKSON
AMSTERDAM

+31 (0)6 4390 8261
jeffre@openintelligenceagency.com

OPEN INTELLIGENCE AGENCY
EMILY REED
SYDNEY

+61 4 1241 9644
emily@openintelligenceagency.com

Russell Davies

russell@openintelligenceagency.com
+44 (0)7976 974 340

OPEN INTELLIGENCE AGENCY

LONDON SYDNEY AMSTERDAM NEW YORK

OPEN INTELLIGENCE AGENCY
DAVID NOTTOLI
NEW YORK

david@openintelligenceagency.com
1 917 207 4387

OPEN INTELLIGENCE AGENCY
EMILY REED
SYDNEY

emily@openintelligenceagency.com
+61 4 1241 9644

OPEN INTELLIGENCE AGENCY
RUSSELL DAVIES
LONDON

russell@openintelligenceagency.com
+44 (0)7976 974 340

OPEN INTELLIGENCE AGENCY
JEFFRE JACKSON
AMSTERDAM

jeffre@openintelligenceagency.com
+31 (0)6 4390 8261

OPEN INTELLIGENCE AGENCY
DAVID NOTTOLI
NEW YORK

1 917 207 4387
david@openintelligenceagency.com

OPEN INTELLIGENCE AGENCY
EMILY REED
SYDNEY

+61 4 1241 9644
emily@openintelligenceagency.com

DESIGN CO.
344 DESIGN, LLC

CLIENT
OPEN INTELLIGENCE AGENCY

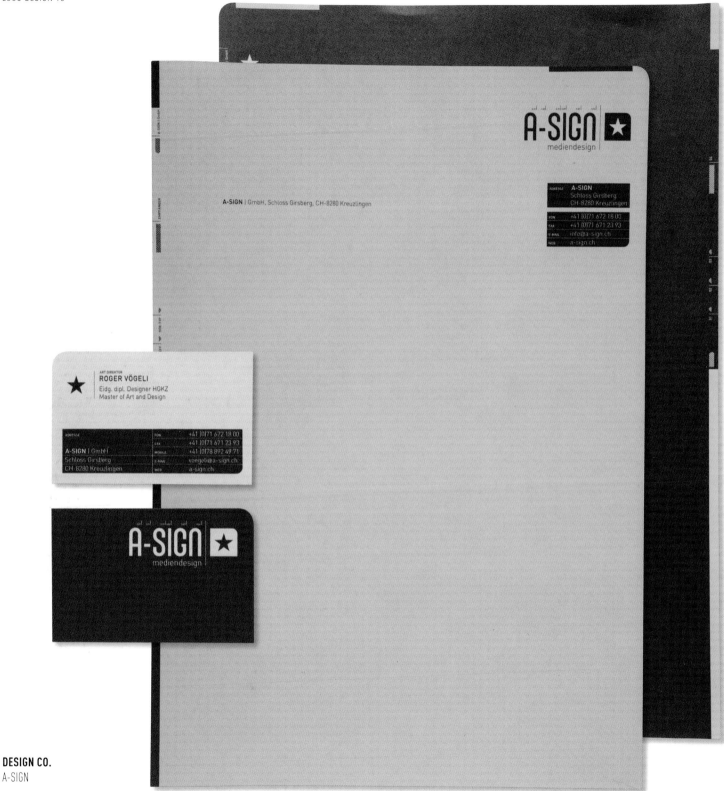

DESIGN CO.
A-SIGN

ART DIRECTOR
PETER KELLER & ROGER VOGELI

CLIENT
A-SIGN

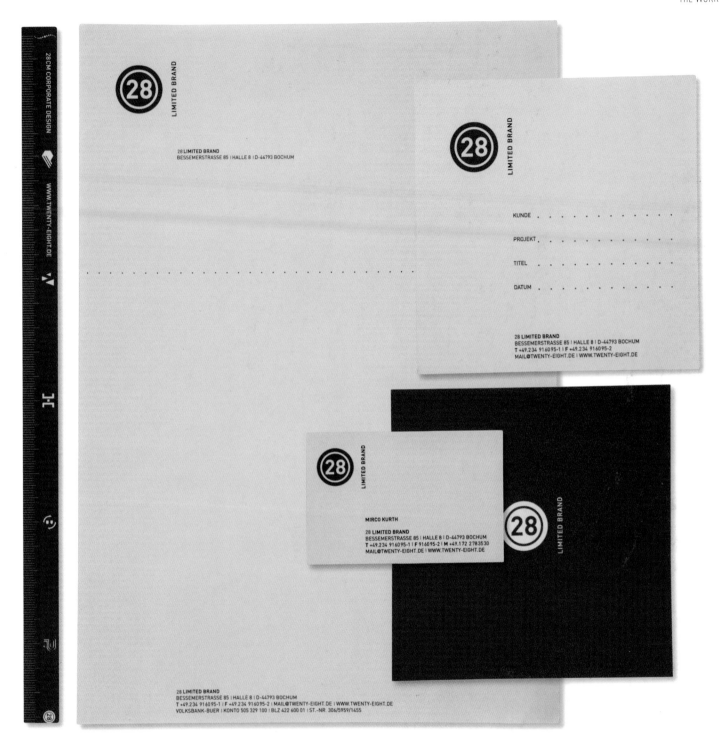

DESIGN CO.
28 LIMITED BRAND

ART DIRECTOR
MIRCO KURTH

DESIGNER
MIRCO KURTH

CLIENT
28 LIMITED BRAND

DESIGN CO.
CUE, INC.

ART DIRECTOR
ALAN COLVIN

DESIGNER
NATE HINZ

CLIENT
CAMPBELL MITHUN

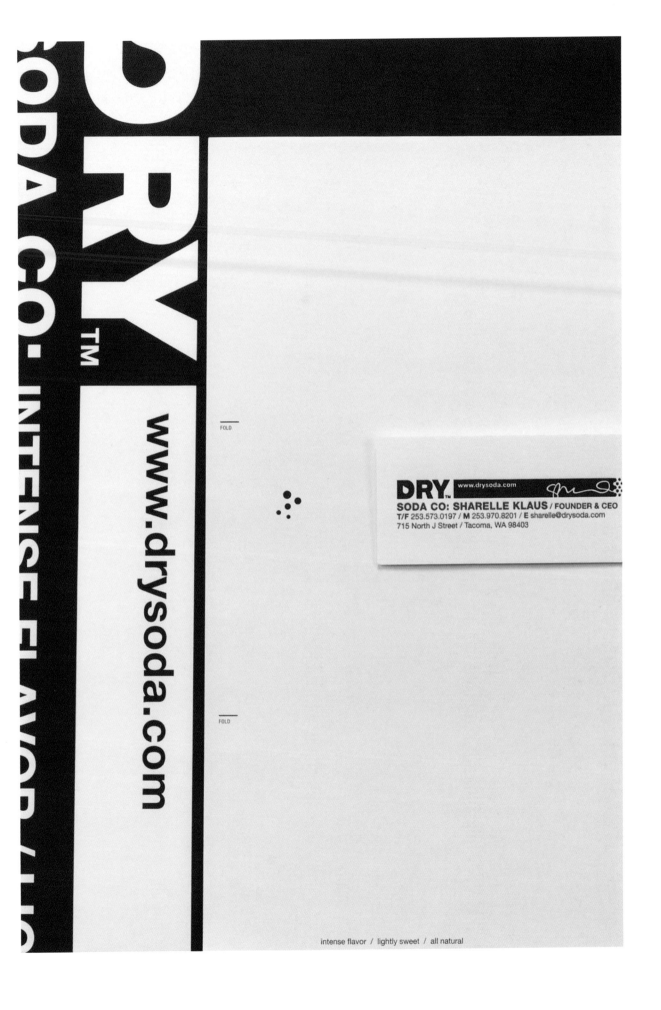

DESIGN CO.
TURNSTYLE

ART DIRECTOR
STEVE WATSON

DESIGNER
STEVE WATSON

CLIENT
DRY SODA COMPANY

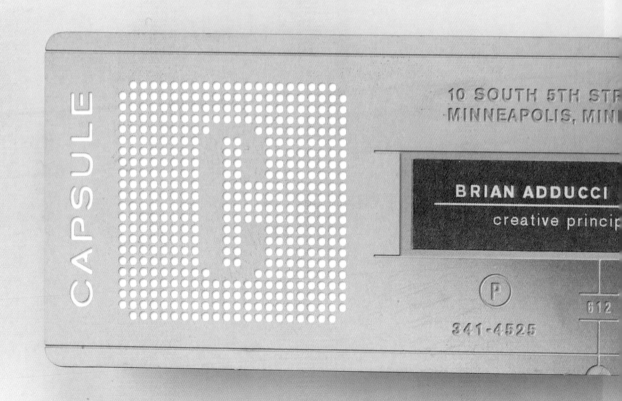

CAPSULE

10 SOUTH 5TH STR
MINNEAPOLIS, MINN

BRIAN ADDUCCI

creative princip

Ⓟ

341-4525

612

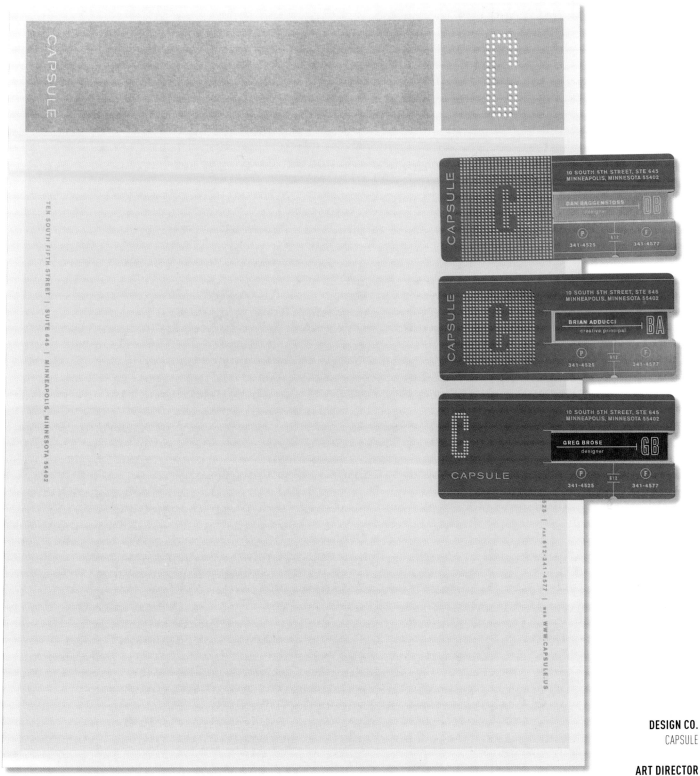

DESIGN CO.
CAPSULE

ART DIRECTOR
BRIAN ADDUCCI

DESIGNER
BRIAN ADDUCCI

CLIENT
CAPSULE

1

DESIGN CO.
BURTON CORPORATION

DESIGNER
TOBY GRUBB

CLIENT
BURTON SNOWBOARDS

DESIGN CO.
A3 DESIGN

ART DIRECTOR
ALAN ALTMAN

DESIGNER
AMANDA ALTMAN

2

CLIENT
LFE

1

2

DESIGN CO.
DESIGN ARMY

ART DIRECTOR
JAKE LEFEBURE & PUM LEFEBURE

DESIGNER
TIM MADLE

CLIENT
SIGNATURE THEATRE

DESIGN CO.
MONO

DESIGNER
TRAVIS OLSON

CLIENT
BLU DOT

1

DESIGN CO.
TIM FRAME DESIGN

ART DIRECTOR
MIKE REGAN

DESIGNER
TIM FRAME

CLIENT
TOURISTEES.COM

DESIGN CO.
SHINE ADVERTISING CO.

ART DIRECTOR
JOHN KRULL

DESIGNER
JOHN KRULL

CLIENT
SHINE ADVERTISING CO.

2

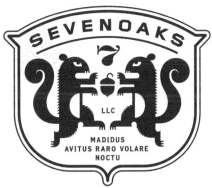

1

2

DESIGN CO.
CUE, INC.

ART DIRECTOR
ALAN COLVIN

DESIGNER
ALAN COLVIN

CLIENT
SEVENOAKS, LLC

DESIGN CO.
TIM FRAME DESIGN

ART DIRECTOR
TIM FRAME

DESIGNER
TIM FRAME

CLIENT
TOURISTEES.COM

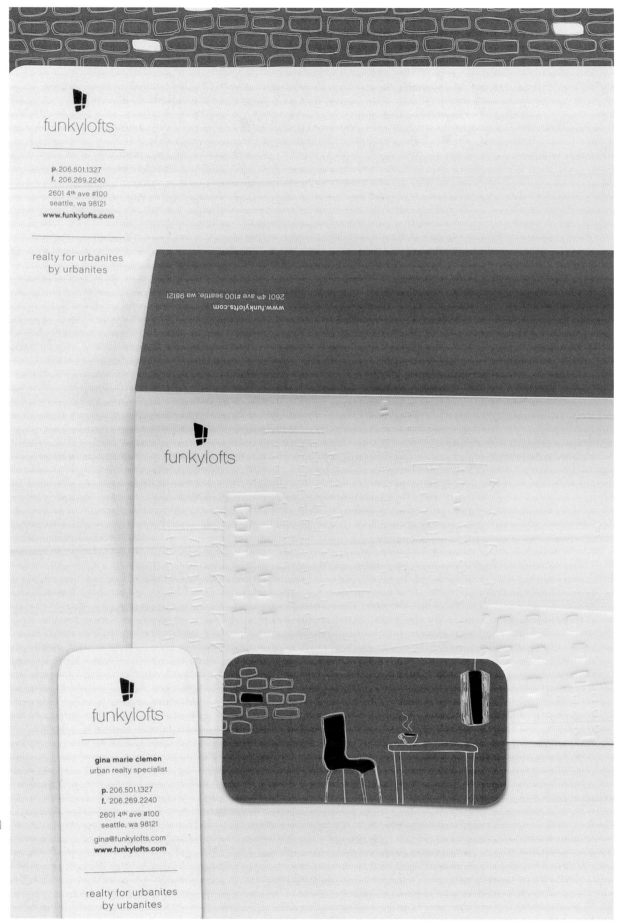

DESIGN CO.
URBANINFLUENCE DESIGN STUDIO

ART DIRECTOR
HENRY YIU

DESIGNER
TODD DUGAN & MIKE MATES

CLIENT
FUNKY LOFTS

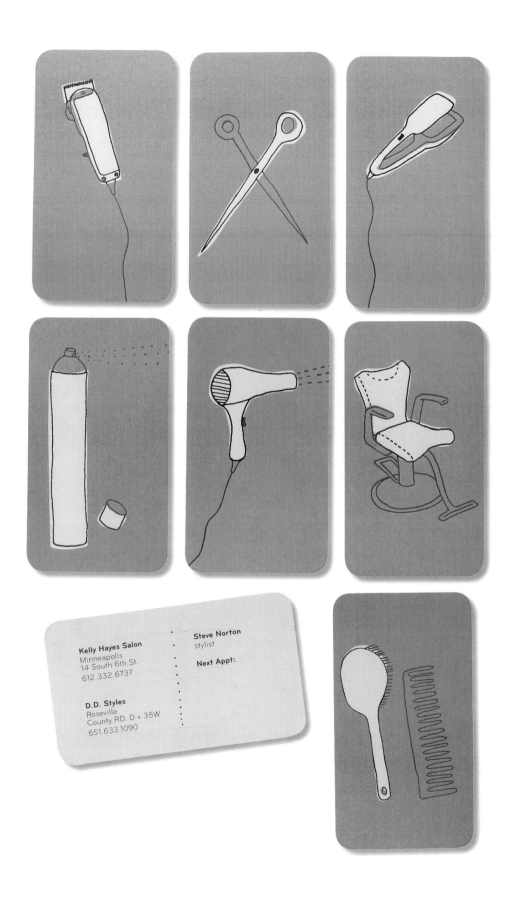

Kelly Hayes Salon
Minneapolis
14 South 6th St.
612.332.6737

Steve Norton
stylist

Next Appt:

D.D. Styles
Roseville
County RD. D + 35W
651.633.1090

DESIGN CO.
GRAPHICULTURE

ART DIRECTOR
CRYSTAL BARLOW

DESIGNER
CRYSTAL BARLOW

CLIENT
STEVE NORTON

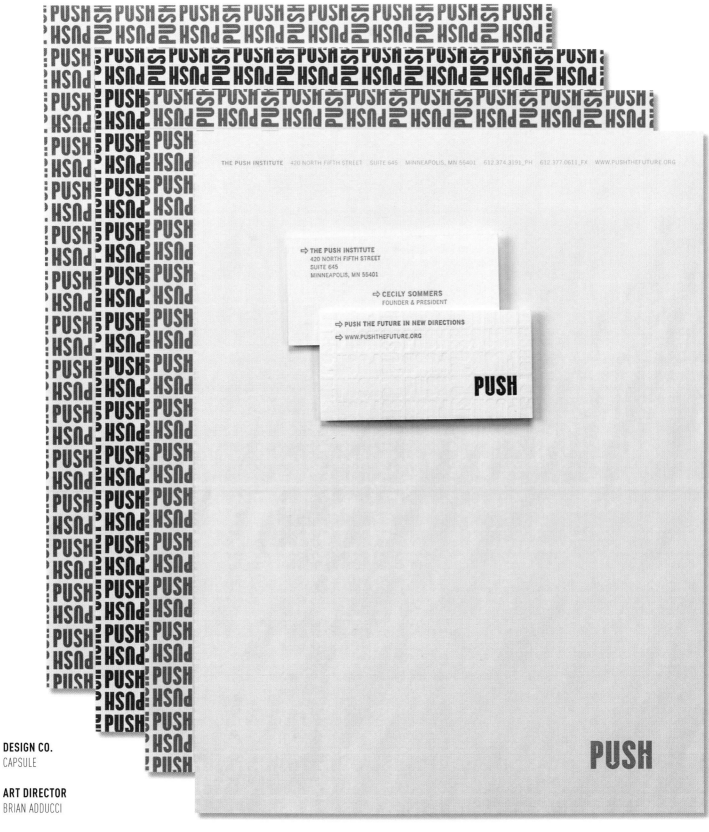

DESIGN CO.
CAPSULE

ART DIRECTOR
BRIAN ADDUCCI

DESIGNER
GREG BROSE

CLIENT
THE PUSH INSTITUTE

DESIGN CO.
CARMICHAEL LYNCH THORBURN

ART DIRECTOR
MICHAEL SKJEI

DESIGNER
TRAVIS OLSON

CLIENT
POETRY SLAM

DESIGN CO.
SAYLES GRAPHIC DESIGN

ART DIRECTOR
JOHN SAYLES

DESIGNER
JOHN SAYLES

CLIENT
MONKEY BID-NESS

DESIGN CO.
MODERN DOG DESIGN CO.

ART DIRECTOR
VITTORIO COSTERELLA & MITCH NASH

DESIGNER
VITTORIO COSTARELLA

CLIENT
BLUE Q

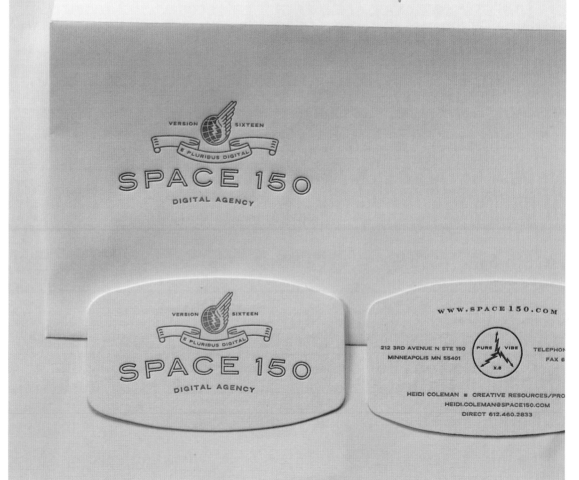

SPACE150.COM
T 612 332 6458 F 612 332 6469

212 3RD AVENUE N STE 150
MINNEAPOLIS MN 55401

DIGITAL DNA
LIVING TOMORROW, TODAY

212 3RD AVENUE N STE 150
MINNEAPOLIS MN 55401

HEIDI COLEMAN PRODUCER
HEIDI.COLEMAN@SPACE150.COM 612 460 2833

212 3RD AVE N STE 150 MINNEAPOLIS MN 55401
SPACE150.COM TEL 612 332 6458 FAX 612 332 6469

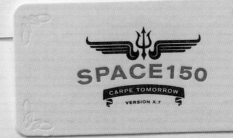

DESIGN CO.
SPACE 150

ART DIRECTOR
BILLY JUREWICZ, RILEY KANE, & JASON STRONG

DESIGNER
BEN LEVITZ

CLIENT
SPACE 150

1

DESIGN CO.
MIRIELLO GRAFICO

DESIGNER
DENNIS GARCIA

CLIENT
QUALCOMM

DESIGN CO.
COLLE + MCVOY

ART DIRECTOR
ED BENNETT

DESIGNER
RYAN CARLSON

CLIENT
FUSION LIFE SPA

2

Media Magnetics
➜ your magnet [here.]

888 Newark Avenue
Jersey City, NJ 07302

800.377.9970
201.792.7244

888 Newark Avenue
Jersey City, NJ 07302

Media M
➜ you

www.mediamagn

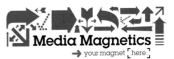

Media Magnetics
➜ your magnet [here.]

DESIGN CO.
3RD EDGE COMMUNICATIONS

ART DIRECTOR
FRANKIE GONZALEZ

DESIGNER
MELISSA MEDINA MACKIN

CLIENT
MEDIA MAGNETICS

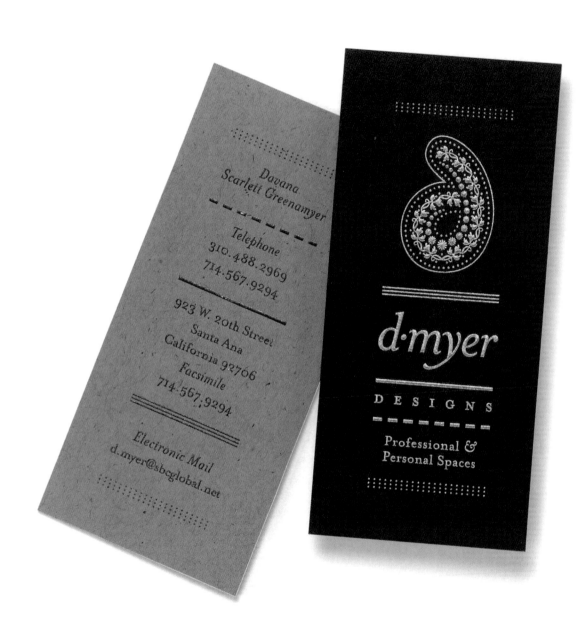

DESIGN CO.
RAMP

ART DIRECTOR
MICHAEL STISNON

DESIGNER
MICHAEL STISNON

CLIENT
DAVANA GREENAMYER

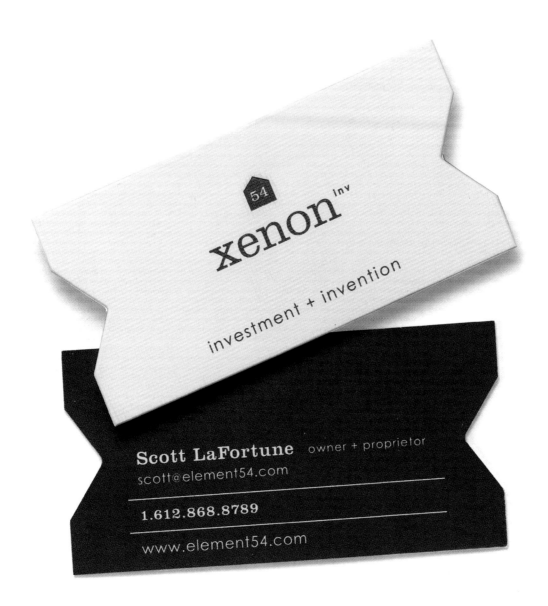

DESIGN CO.
FAUXKOI DESIGN CO.

DESIGNER
DAN WEST

CLIENT
XENON INV.

1

DESIGN CO.
EIGHTHOURDAY

ART DIRECTOR
KATIE KIRK & NATHAN STRANDBERG

DESIGNER
KATIE KIRK & NATHAN STRANDBERG

CLIENT
TIMBERWOLVES

DESIGN CO.
DESIGN ARMY

ART DIRECTOR
JAKE LEFEBURE & PUM LEFEBURE

DESIGNER
PUM LEFEBURE

CLIENT
BOUTIQUE@U

2

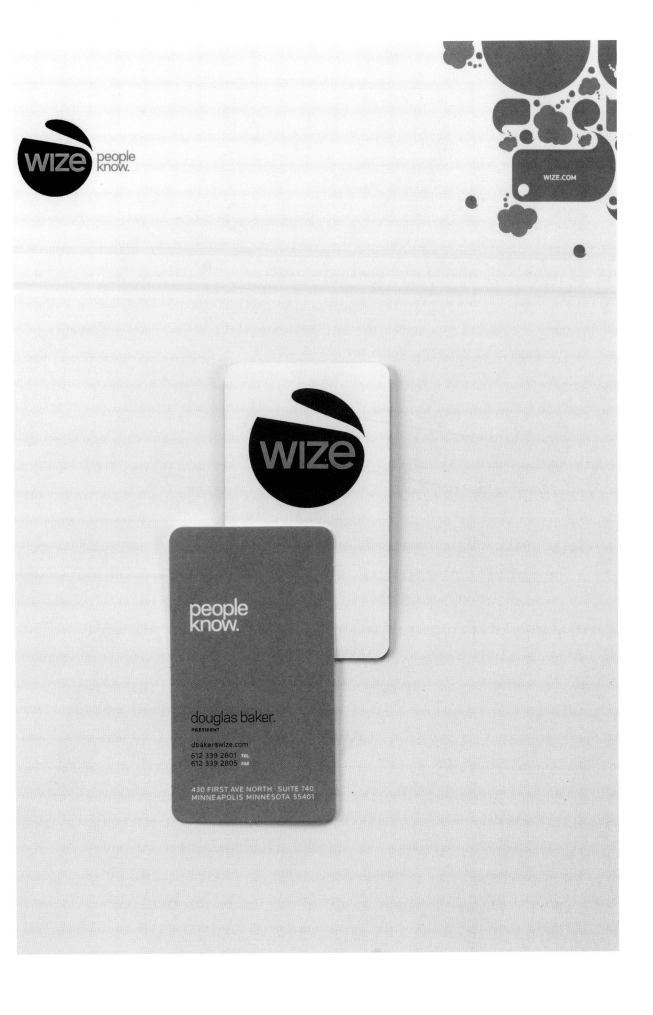

DESIGN CO.
BAMBOO

ART DIRECTOR
KATHY SORANNO

DESIGNER
KATHY SORANNO

CLIENT
WIZE.COM

235 DEKALB INDUSTRIAL WAY, DECATUR, GA 30030
1.866.PADDYWAX *tel* 404.378.7422 *fax* 404.378.7423

WWW.PADDYWAX.COM

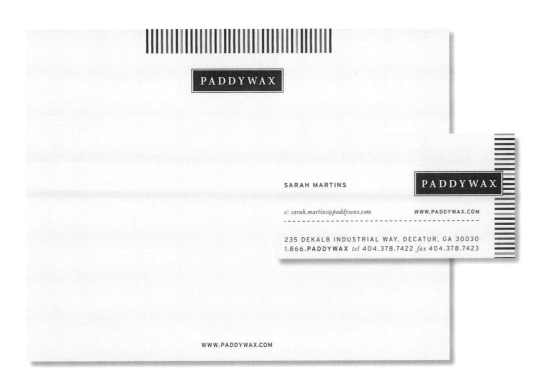

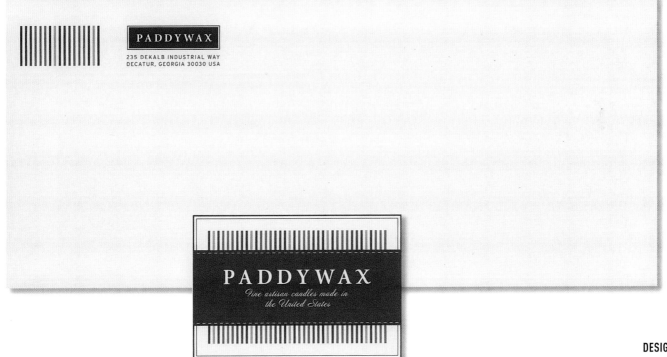

DESIGN CO.
PRINCIPLE, INC.

ART DIRECTOR
PAMELA ZUCCKER

DESIGNER
PAMELA ZUCCKER

CLIENT
PADDYWAX

Kinetic
Design & Advertising
Private Limited
Kinetic Interactive
Private Limited
2 Leng Kee Road
#04-03A #03-02
Thye Hong Centre
Singapore 159086
Telephone.6475.9380
Facsimile.6472.5440
www.kinetic.com.sg

A Member of the Ad Planet Group

We've moved

but the forests are moving even faster. As much as 5000 sq. miles of forests are lost annually in Southeast Asia alone. You'd agree that every little bit of paper recycled counts, even if it's just one tiny piece of office stationery.

Kinetic
Design & Advertising
Private Limited
Kinetic Interactive
Private Limited
2 Leng Kee Road
#04-03A #03-02
Thye Hong Centre
Singapore 159086
Telephone.6475.9380
Facsimile.6472.5440
www.kinetic.com.sg

A Member of the Ad Planet Group

We've moved

but the forests are moving even faster. Recycling paper not only saves trees but also cuts down emissions of greenhouse gases and the need for landfill space. You'd agree that every little bit counts, even if it's just one envelope.

Roy Poh
Art Director
roy@kinetic.com.sg
www.kinetic.com.sg
Kinetic Design
& Advertising
Private Limited
2 Leng Kee Road
#04-03A #03-02
Thye Hong Centre
Singapore 159086
Handphone.9767.2355
Telephone.6379.5320
Facsimile.6472.5440

A Member of the Ad Planet Group

We've moved

but the forests are moving even faster. In fact, thousands of trees are being chopped down every minute to feed our insatiable thirst for paper. You'd agree that every little bit of paper recycled helps, even if it's just one business card.

DESIGN CO.
KINETIC

ART DIRECTOR
PANN LIM & ROY POH

DESIGNER
GEN TAN

CLIENT
KINETIC SINGAPORE

DESIGN CO.
SO DESIGN CO.

ART DIRECTOR
AARON POLLOCK

DESIGNER
AARON POLLOCK

CLIENT
@M. INTERACTIVE, INC.

Go ahead, it's your crop.

VORDERMAN
PHOTOGRAPHY

lisa@vordermanphoto.com

Lisa Wylie
P.O. Box 173
___ n Street
___ N 46783
___ 1557 p
___ 1556 f

...ping!

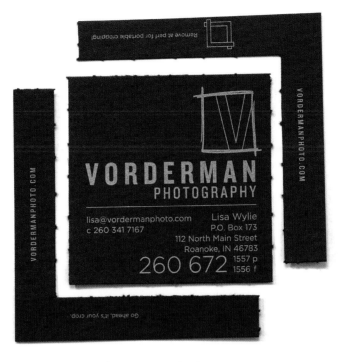

DESIGN CO.
ONE LUCKY GUITAR

ART DIRECTOR
MATT KELLEY

DESIGNER
MATT KELLEY

CLIENT
VORDERMAN PHOTOGRAPHY

cube3

1

DESIGN CO.
OCTAVO DESIGN

ART DIRECTOR
GARY DOMONEY

DESIGNER
GARY DOMONEY

CLIENT
CUBE³ DEVELOPERS

DESIGN CO.
SO DESIGN CO.

ART DIRECTOR
AARON POLLOCK

DESIGNER
AARON POLLOCK

CLIENT
ONE ON ONE

2

NORTH
LOOP
NEIGHBORHOOD

1

S A I N T
BY SARAH JANE

2

DESIGN CO.
LITTLE AND COMPANY

ART DIRECTOR
JOE CECERE

DESIGNER
JOE CECERE

CLIENT
NORTH LOOP NEIGHBORHOOD

DESIGN CO.
GRETEMAN GROUP

ART DIRECTOR
SONIA GRETEMAN

DESIGNER
CRAIG TOMSON

CLIENT
SAINT BY SARAH JANE

DESIGN CO.
SHINE ADVERTISING CO.

ART DIRECTOR
MIKE KRIEFSKI

DESIGNER
MIKE KRIEFSKI

CLIENT
UMI

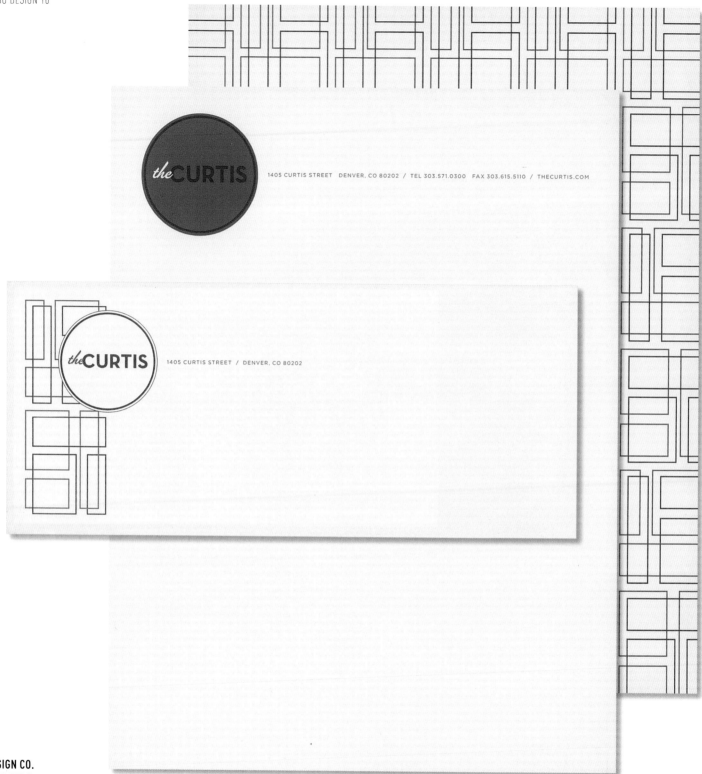

DESIGN CO.
KORN DESIGN

ART DIRECTOR
DENISE KORN

DESIGNER
BRYANT ROSS

CLIENT
SAGE HOSPITALITY GROUP

1

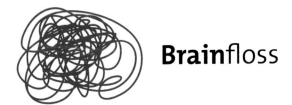

2

DESIGN CO.
MINE™

ART DIRECTOR
CHRISTOPHER SIMMONS

DESIGNER
CHRISTOPHER SIMMONS

CLIENT
BRAINFLOSS

DESIGN CO.
RYAN COOPER DESIGN

ART DIRECTOR
RYAN COOPER

DESIGNER
RYAN COOPER

CLIENT
DR. MICHAEL FORD D. D. S. P. C.

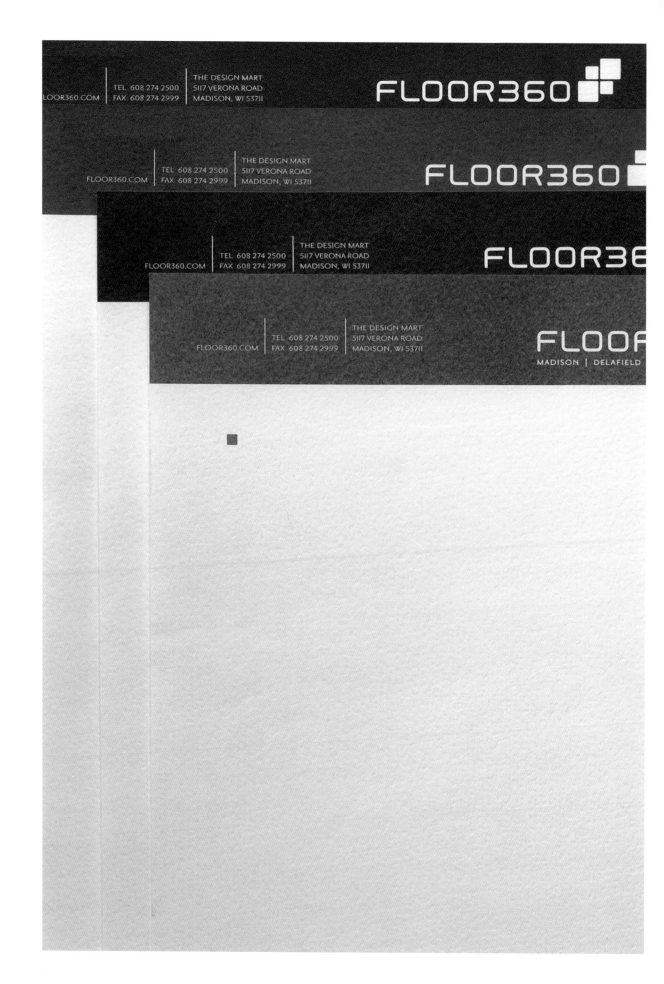

DESIGN CO.
SHINE ADVERTISING CO.

ART DIRECTOR
MIKE KRIEFSKI

DESIGNER
EMILIE SMITH

CLIENT
FLOOR 360

ART DIRECTOR
ANNE JOHNSON

DESIGNER
ANNE JOHNSON

CLIENT
WOODCRAFT, INC.

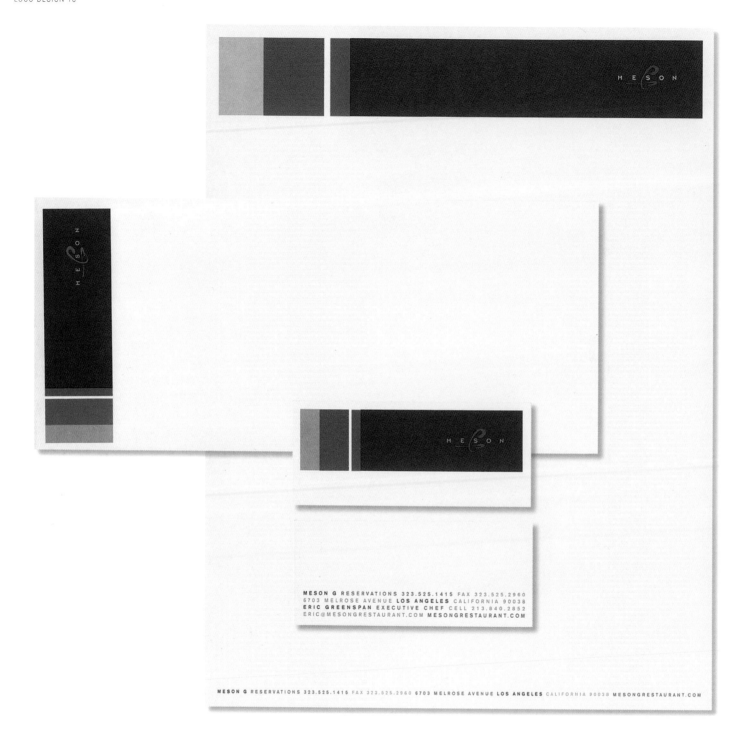

DESIGN CO.
RAMP

ART DIRECTOR
RACHEL ELNAR & MICHAEL STISNON

DESIGNER
MICHAEL STISNON

CLIENT
DOMANINE RESTAURANTS LTD

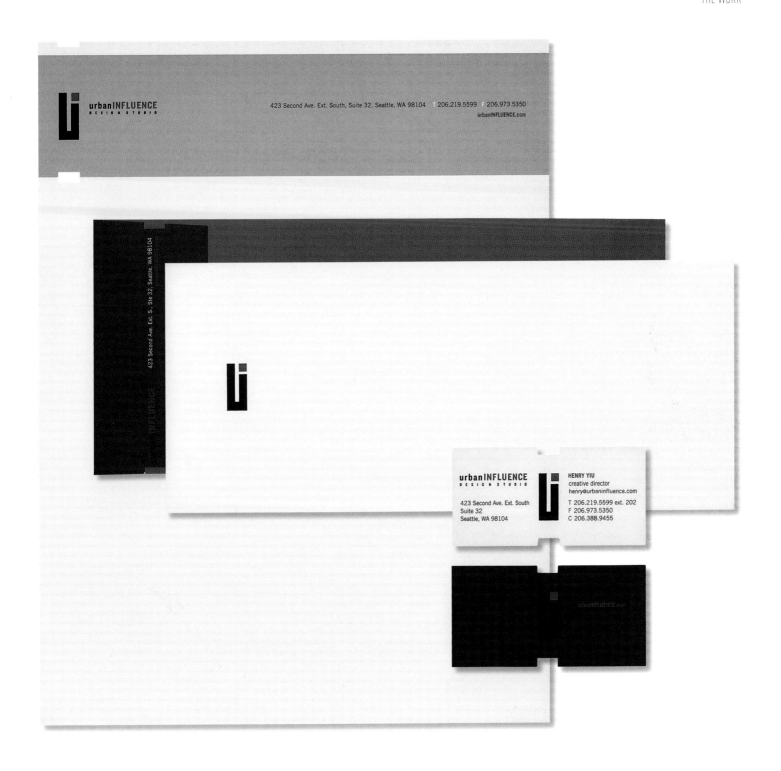

DESIGN CO.
URBANINFLUENCE DESIGN STUDIO

ART DIRECTOR
HENRY YIU

DESIGNER
HENRY YIU

CLIENT
URBANINFLUENCE DESIGN STUDIO

DESIGN CO.
A3 DESIGN

ART DIRECTOR
ALAN ALTMAN

DESIGNER
AMANDA ALTMAN

CLIENT
CARBON HOUSE

Textile Building
119 North 4th Street #400
Minneapolis, MN 55401

ph 612.338.4462
fx 612.338.1875
www.designguys.com

DesignGuysinc.

DESIGN CO.
DESIGN GUYS

ART DIRECTOR
STEVE SIKORA

DESIGNER
JAY THEIGE

CLIENT
DESIGN GUYS

uearn.com

1

DESIGN CO.
GULLA DESIGN

ART DIRECTOR
STEVE GULLA

DESIGNER
STEVE GULLA

CLIENT
UEARN.COM

2

DESIGN CO.
ROCKETDOG COMMUNICATIONS

ART DIRECTOR
SUSAN ELLIOTT

DESIGNER
DAMON NAKAGAWA

CLIENT
THE STATION

WALMARTWATCH.COM

3

DESIGN CO.
DESIGN ARMY

ART DIRECTOR
JAKE LEFEBURE & PUM LEFEBURE

DESIGNER
TIM MADLE

CLIENT
WALMART WATCH

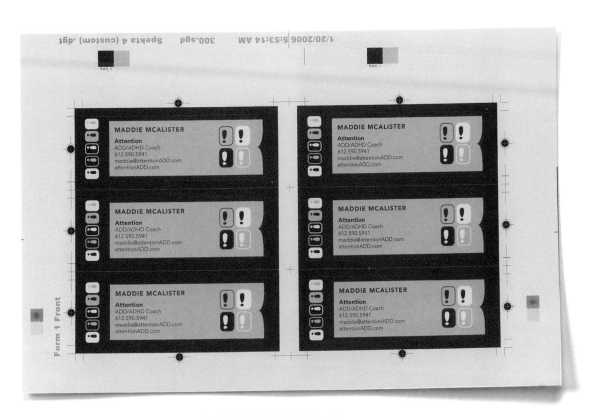

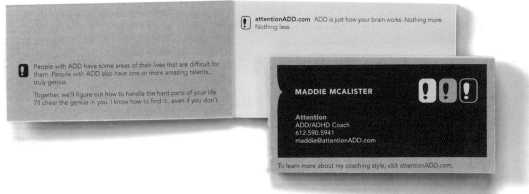

DESIGN CO.
CATALYST STUDIOS

ART DIRECTOR
SHANNON RETTINI

DESIGNER
JODI ECKES

CLIENT
ATTENTION

1

DESIGN CO.
LEWIS COMMUNICATIONS

DESIGNER
CLARK HOOK

CLIENT
CASEY BRAY

DESIGN CO.
CATALYST STUDIOS

ART DIRECTOR
SHANNON RETTINI

DESIGNER
JODI ECKES

CLIENT
FLYING COLORS

2

1

2

DESIGN CO.
RAMP

ART DIRECTOR
MICHAEL STISNON

DESIGNER
ANGELA KIM

CLIENT
GLOBAL FIRE & TECH

DESIGN CO.
CARMICHAEL LYNCH THORBURN

ART DIRECTOR
BILL THORBURN

DESIGNER
STEVE JOCKISCH

CLIENT
CARMICHAEL LYNCH THORBURN

O
BS
ERV
ABLE
—
BOOKS

1

DESIGN CO.
TOKY BRANDING + DESIGN

ART DIRECTOR
ERIC THOELKE

DESIGNER
BENJAMIN FRANKLIN

CLIENT
OBSERVABLE BOOKS

DESIGN CO.
GIOTTO

ART DIRECTOR
SILVIO GIORGI

DESIGNER
SANDRO GIORGI & SILVIO GIORGI

CLIENT
LINKS COMMUNICATIONS

2

1

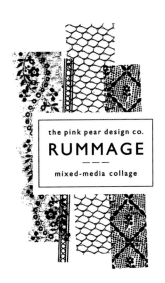

2

DESIGN CO.
URBAN SKETCH

ART DIRECTOR
ADAM HOGANSON

DESIGNER
ADAMN HOGANSON

CLIENT
MATCH TWO

DESIGN CO.
THE PINK PEAR DESIGN COMPANY

ART DIRECTOR
SARAH SMITKA

DESIGNER
SARAH SMITKA

CLIENT
RUMMAGE BY PINK PEAR DESIGN CO.

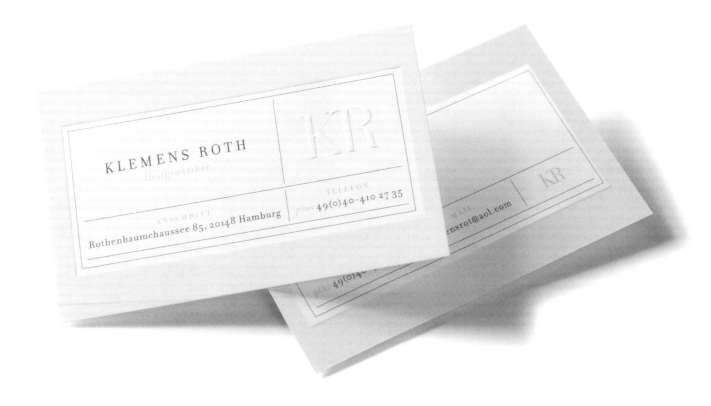

DESIGN CO.
MARIUS FAHRNER DESIGN

ART DIRECTOR
MARIUS FAHRNER

DESIGNER
MARIUS FAHRNER

CLIENT
MR. ROTH

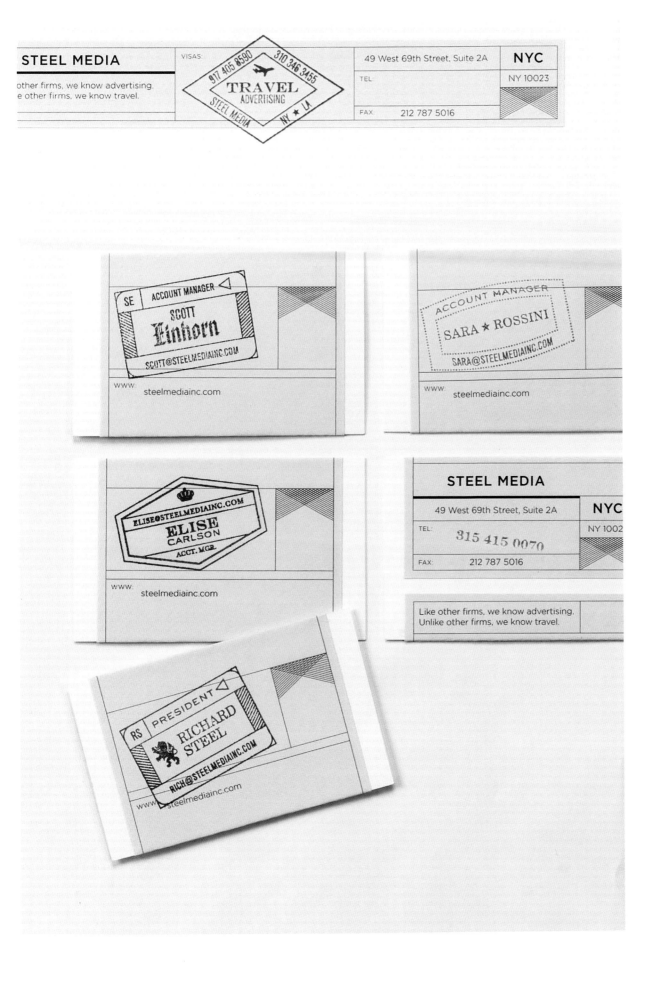

DESIGN CO.
MINE™

ART DIRECTOR
CHRISTOPHER SIMMONS

DESIGNER
CHRISTOPHER SIMMONS

CLIENT
STEEL MEDIA

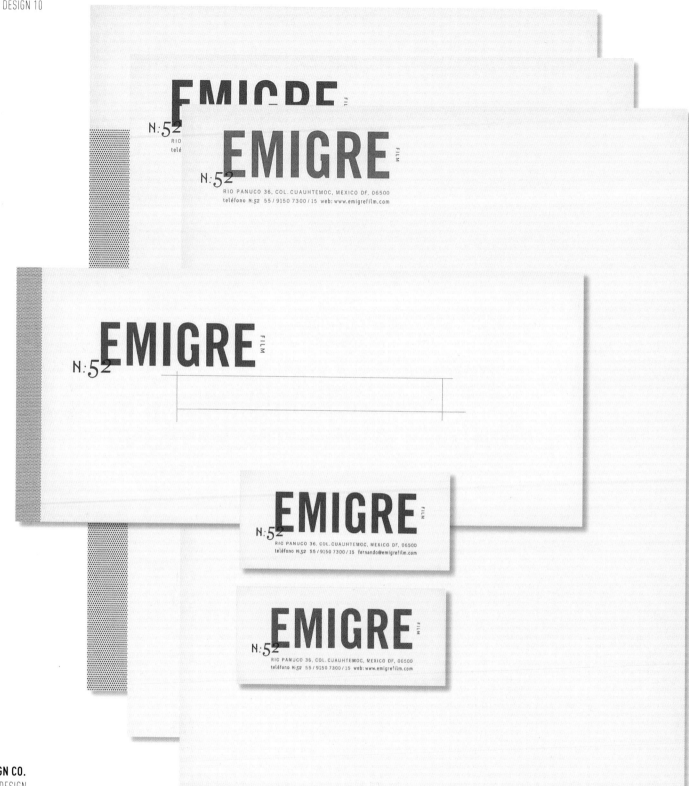

DESIGN CO.
BLOK DESIGN

ART DIRECTOR
VANESSA ECKSTEIN

DESIGNER
MARIANA CONTEGNI & PATRICIA KLEEBERG

CLIENT
EMIGRE FILM

W Y H
I O U
N U I
G N E
G

THANKS!

2525 EAST FRANKLIN AVENUE. SUITE 100. MINNEAPOLIS. MN 55406
TEL. 612 375 0191 info@wingyounghuie.com www.wingyounghuie.com

W Y H
I O U
N U I
G N E
G

2525 EAST FRANKLIN AVENUE
SUITE 100. MINNEAPOLIS
MN 55406. TEL. 612 375 0191

info@wingyounghuie.com
www.wingyounghuie.com

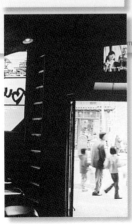

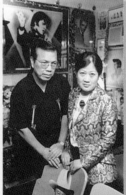

DESIGN CO.
SO DESIGN CO.

ART DIRECTOR
AARON POLLOCK

DESIGNER
AARON POLLOCK

CLIENT
WING YOUNG HUIE

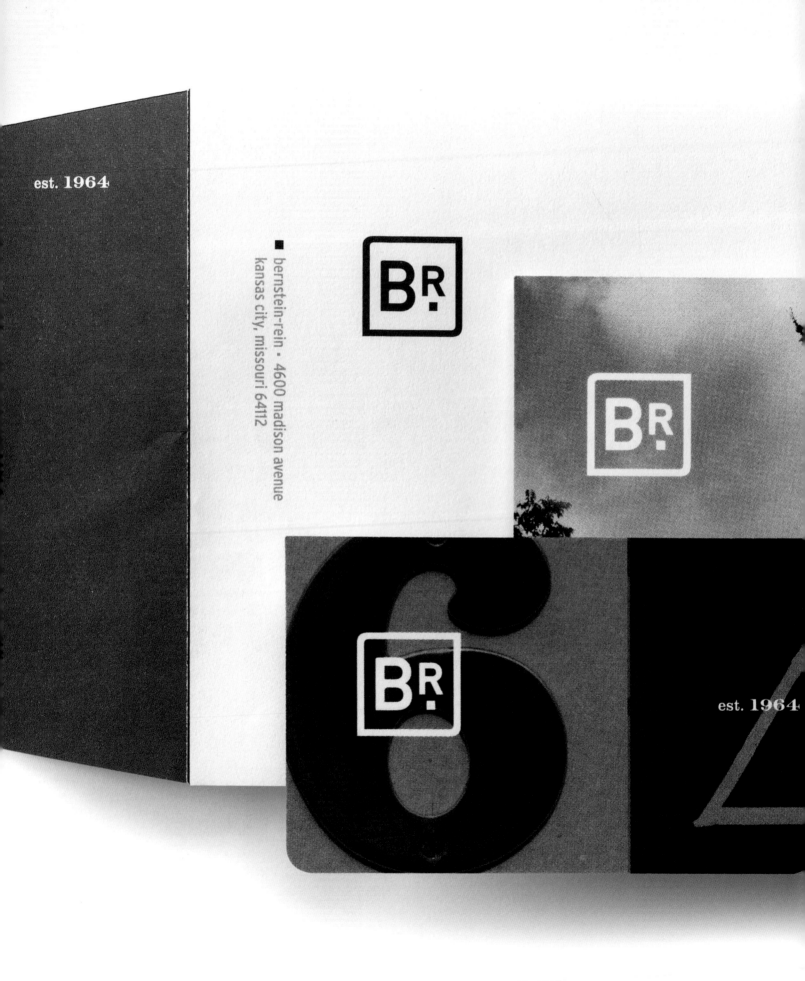

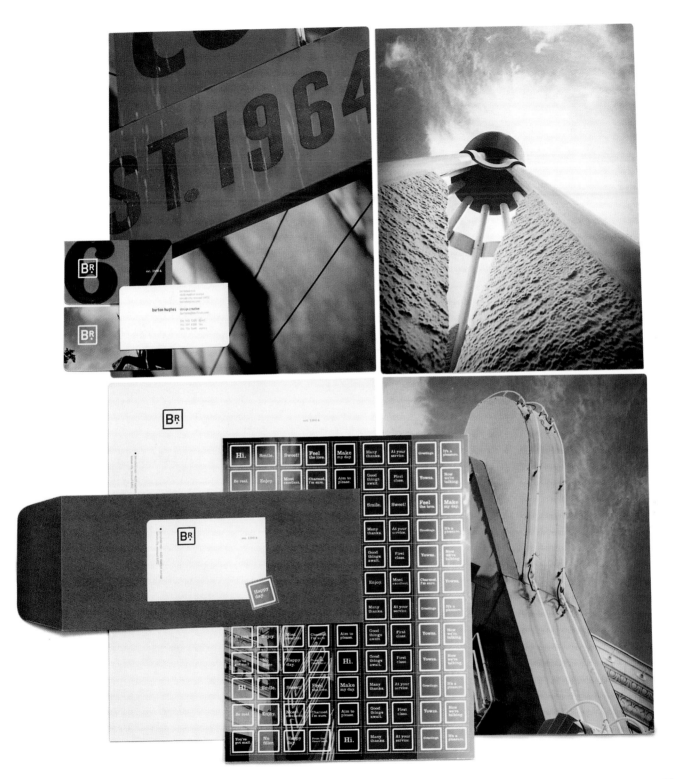

DESIGN CO.
BR: VERSE

ART DIRECTOR
NATHANIEL COOPER, KRISTA MASILIONIS,
& FRANKLIN OVIEDO

DESIGNER
FRANKLIN OVIEDO

CLIENT
BERNSTEIN-REIN ADVERTISING

THERMAL TECH ICONS R3

STINK PROOF

STRETCH 360

STRETCH 180

SOFTWRAP

SOFTLOCK

SOFTWAIST

DRY-WICK

NEUEWOOL

PLUS SLEEVES

SHANTLEG

POCKET TECH

DESIGN CO.
BURTON CORPORATION

ART DIRECTOR
TOBY GRUBB

DESIGNER
ADAM WEISS

CLIENT
BURTON SNOWBOARDS

1

DESIGN CO.
DESIGN RANCH

ART DIRECTOR
INGRED SIDIE & MICHELLE SONDEREGGER

DESIGNER
TAD CARPENTER

CLIENT
RAETA ESTATES

DESIGN CO.
FAUXKOI DESIGN CO.

DESIGNER
DAN WEST

CLIENT
ANDREW GRANT

2

1

2

DESIGN CO.
DESIGN RANCH

ART DIRECTOR
INGRED SIDIE & MICHELLE SONDEREGGER

DESIGNER
INGRED SIDIE & MICHELLE SONDEREGGER

CLIENT
RIVER BLUFF

DESIGN CO.
DESIGN RANCH

ART DIRECTOR
INGRED SIDIE & MICHELLE SONDEREGGER

DESIGNER
BRYNN JOHNSON

CLIENT
NOVO DIEM

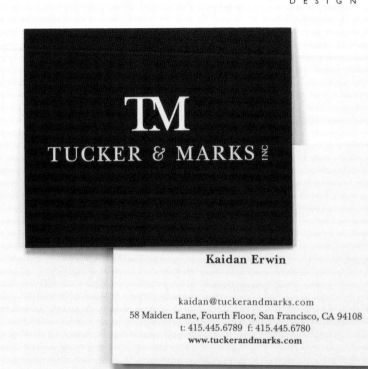

DESIGN CO.
KAA DESIGN GROUP, INC.

ART DIRECTOR
MELANIE ROBINSON

DESIGNER
CHRISTINA CHENG & ANNETTE LEE

CLIENT
TUCKER & MARKS, INC.

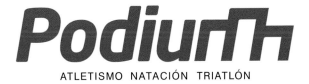

ATLETISMO NATACIÓN TRIATLÓN

1

DESIGN CO.
GIOTTO

ART DIRECTOR
SILVIO GIORGI

DESIGNER
SANDRO GIORGI & SILVIO GIORGI

CLIENT
PODIUM

VERT|CA

2

DESIGN CO.
GIOTTO

ART DIRECTOR
SILVIO GIORGI

DESIGNER
SANDRO GIORGI & SILVIO GIORGI

CLIENT
VERTICA

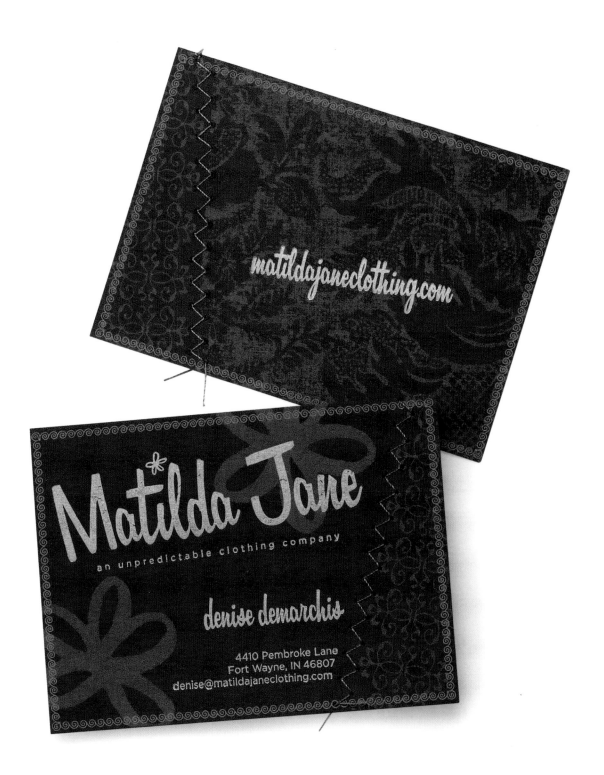

DESIGN CO.
ONE LUCKY GUITAR

ART DIRECTOR
MATT KELLEY

DESIGNER
MATT KELLY

CLIENT
MATILDA JANE CLOTHING CO.

DESIGN CO.
MINE™

ART DIRECTOR
CHRISTOPHER SIMMONS

DESIGNER
TIM BELONAX

CLIENT
ROCKPORT PUBLISHERS

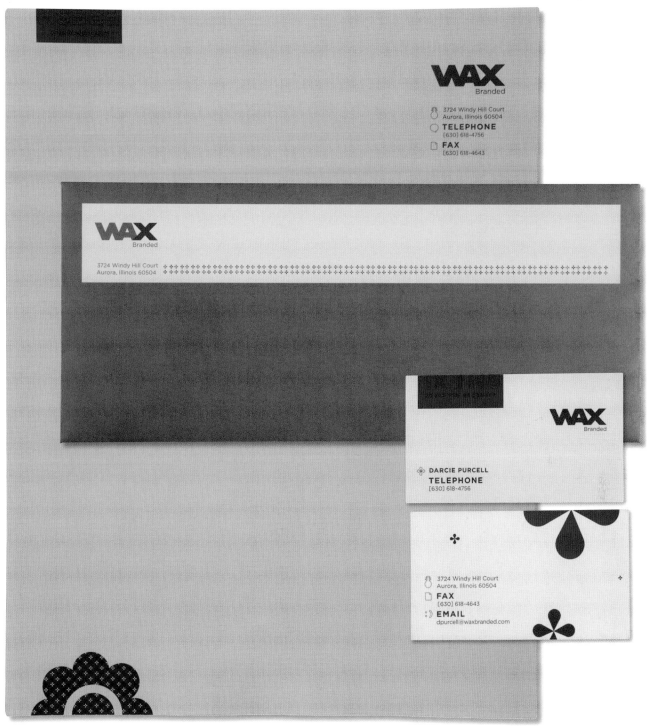

DESIGN CO.
BAMBOO

ART DIRECTOR
KATHY SORANNO

DESIGNER
KATHY SORANNO

CLIENT
WAX BRANDED

BURLWOOD

701 XENIA AVENUE SOUTH, SUITE
MINNEAPOLIS, MINNESOTA 5541
PH 763-231-7170 TF 866-886-9250 FX 76
WS WWW.BURLWOODFINANCIAL.C

BURLWOOD FINANCIAL GROUP, INC.
701 XENIA AVENUE SOUTH, SUITE 270
MINNEAPOLIS, MINNESOTA 55416

BURLWOOD

JENNIFER KREGER *Operations Manager & Registered Assistant*
DT 763-231-7173 EM JKREGER@BURLWOODFINANCIAL.COM

BURLWOOD FINANCIAL GROUP, INC.
701 XENIA AVENUE SOUTH, SUITE 270 MINNEAPOLIS, MN 55416
PH 763-231-7170 TF 866-886-9250 FX 763-231-7189

...TIES OFFERED THROUGH FELTL AND COMPANY - MEMBER NASD/SIPC

BURLWOOD FINANCIAL GROUP, INC.
SECURITIES OFFERED THROUGH FELTL AND COMPANY - MEMBER NASD/SIPC
ACCOUNTS CARRIED WITH NATIONAL FINANCIAL SERVICES, LLC - MEMBER NYSE/SIPC

DESIGN CO.
CAPSULE

ART DIRECTOR
BRIAN ADDUCCI

DESIGNER
GREG BROSE

CLIENT
BURLWOOD FINANCIAL GROUP, INC.

1

2

DESIGN CO.
FOX CREATIVE

ART DIRECTOR
ADAM FOX

DESIGNER
ADAM FOX

CLIENT
FOX CREATIVE

DESIGN CO.
BR: VERSE

ART DIRECTOR
ANTHONY MAGLIANO & FRANKLIN OVIEDO

DESIGNER
ANTHONY MAGLIANO & FRANKLIN OVIEDO

CLIENT
PARISI ARTISIAN COFFEE

9 Music Square South No. 108
Nashville, TN 37203

a letter for:

DESIGN CO.
LEWIS COMMUNICATIONS

DESIGNER
CLARK HOOK

CLIENT
SCOTT PARKER

calling card

9 Music Square South
Nashville, TN 37203

please deliver to:

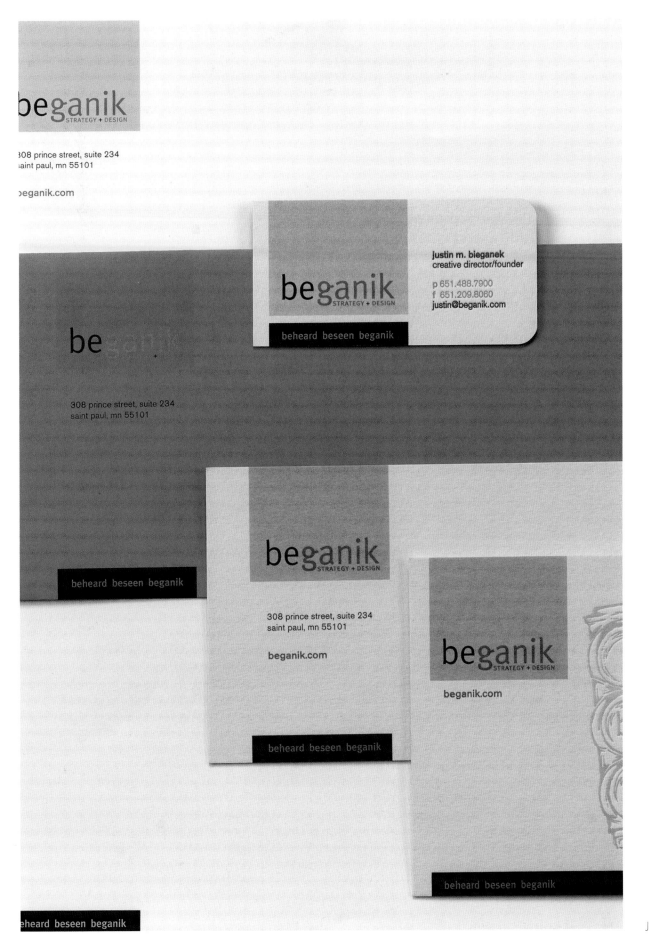

DESIGN CO.
BEGANIK

ART DIRECTOR
JUSTIN BIEGANEK

DESIGNER
JODI ECKES & RYAN TUNGSETH

CLIENT
BEGANIK

DESIGN CO.
ARCHRIVAL

ART DIRECTOR
CHARLES HULL

DESIGNER
JOEL KREUTZER

CLIENT
LA FLEUR ORGANIQUE

DESIGN CO.
SOMMESE DESIGN

ART DIRECTOR
KRISTIN SOMMESE &
LANNY SOMMESE

DESIGNER
RYAN RUSSELL

CLIENT
LAUTH DEVELOPERS

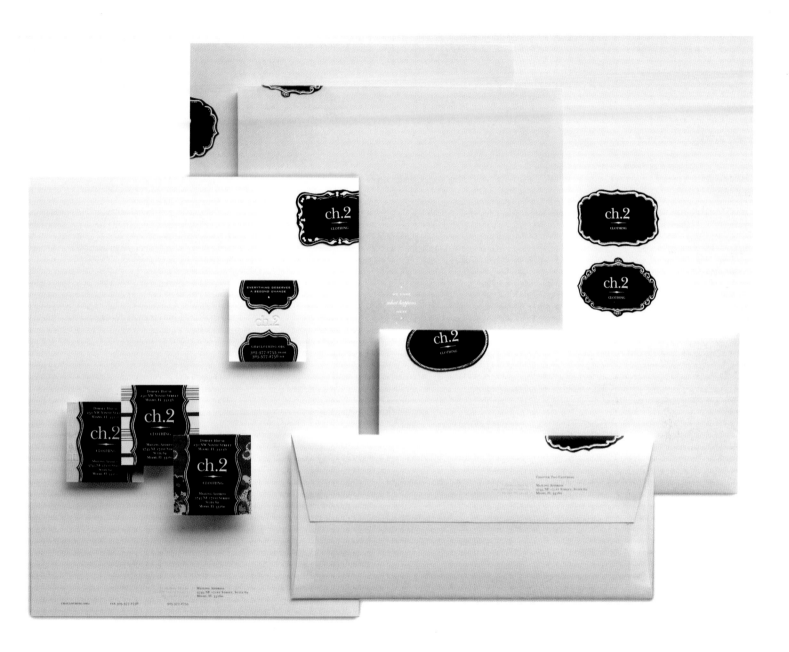

DESIGN CO.
MONO

DESIGNER
TRAVIS OLSON

CLIENT
WOMEN'S ALLIANCE

DESIGN CO.
DESIGN RANCH

ART DIRECTOR
INGRED SIDIE &
MICHELLE SONDEREGGER

DESIGNER
TAD CARPENTER

CLIENT
RAETA ESTATES

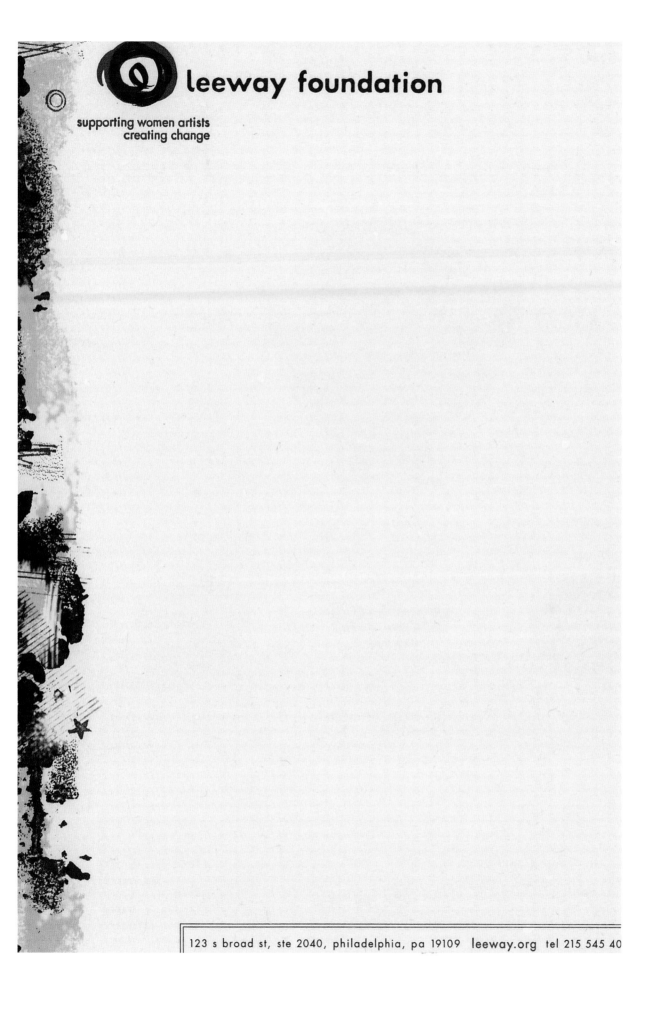

leeway foundation

supporting women artists
creating change

123 s broad st, ste 2040, philadelphia, pa 19109 leeway.org tel 215 545 40

DESIGN CO.
FIREBELLY DESIGN

ART DIRECTOR
DAWN HANCOCK

DESIGNER
ANTONIO GARCIA &
DAWN HANCOCK

CLIENT
LEEWAY FOUNDATION

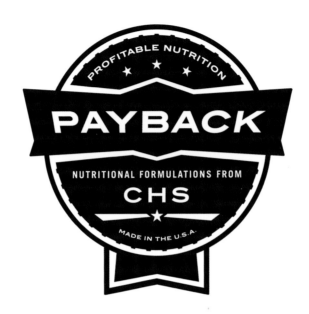

DESIGN CO.
COLLE + MCVOY

ART DIRECTOR
ED BENNETT

DESIGNER
RYAN CARLSON

CLIENT
CHS INC.

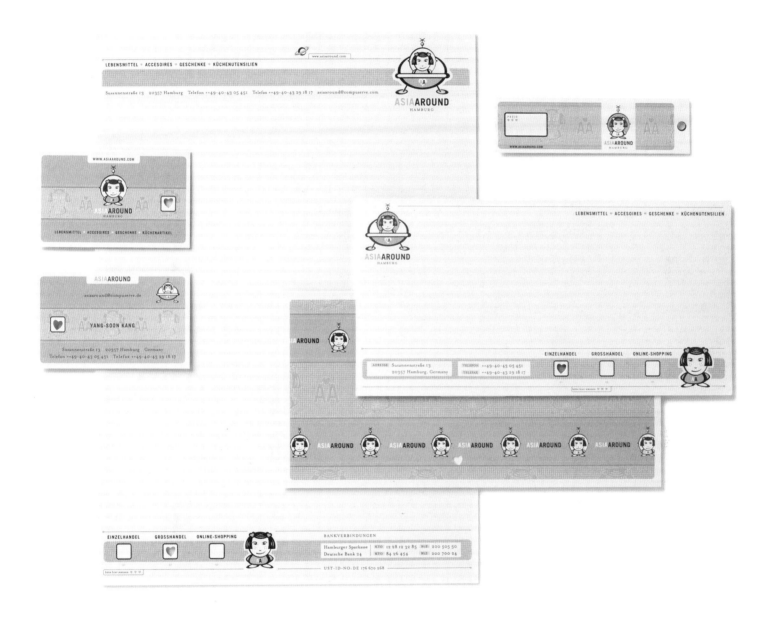

DESIGN CO.
MARIUS FAHRNER DESIGN

ART DIRECTOR
MARIUS FAHRNER

DESIGNER
MARIUS FAHRNER

CLIENT
YANGSOON YANG

234, rue **Baronet**, C.P. 580
Sainte-Marie (Québec)
Canada G6E 3B8
T. 418 387-5431
F. 418 387-3028
http://www.baronet.ca

234, rue **Baronet**, C.P. 580
Sainte-Marie (Québec)
Canada G6E 3B8
T. 418 387-5431
F. 418 386-4427
http://www.baronet.ca

Paul Vallée
Directeur financier
pvallee@baronet.ca

234, rue **Baronet**, C.P. 580
Sainte-Marie (Québec)
Canada G6E 3B8
T. 418 387-5431
F. 418 387-3028
http://www.baronet.ca

234, rue **Baronet**, C.P. 580
Sainte-Marie (Québec)
Canada G6E 3B8
T. 418 387-5431
F. 418 387-3028
http://www.baronet.ca

234, rue **Baronet**, C.P. 580
Sainte-Marie (Québec)
Canada G6E 3B8
T. 418 387-5431
F. 418 386-4427
http://www.baronet.ca

Paul Vallée
Directeur financier
pvallee@baronet.ca

DESIGN CO.
PAPRIKA

ART DIRECTOR
LOUIS GAGNON

DESIGNER
RENE CLEMENT

CLIENT
BARONET

1

DESIGN CO.
LOVELY

DESIGNER
KEVIN HAYES & DUSTIN
SPARKS

CLIENT
EOC EDUTAINMENT

DESIGN CO.
MINT DESIGN INC.

ART DIRECTOR
MIKE CALKINS & RYAN JACOBS

DESIGNER
MIKE CALKINS

CLIENT
MTV

2

1

2

DESIGN CO.
IMAGEHAUS

ART DIRECTOR
JAY MILLER

DESIGNER
JAMIE PAUL

CLIENT
UNIVERSITY OF MINNESOTA - SCHOOL OF MUSIC

DESIGN CO.
GO WELSH

ART DIRECTOR
CRAIG WELSH

DESIGNER
RYAN SMOKER

CLIENT
MUSIC FOR EVERYONE

1

DESIGN CO.
WESTMORELANDFLINT

ART DIRECTOR
KEN ZAKOVICH

DESIGNER
KEN ZAKOVICH

CLIENT
UNIVERSITY OF MINNESOTA-DULUTH SCHOOL OF FINE ARTS

DESIGN CO.
INITIO

DESIGNER
RANDY PIERCE

CLIENT
COMMONWEAL THEATRE COMPANY

2

1

2

DESIGN CO.
CUE, INC.

ART DIRECTOR
ALAN COLVIN

DESIGNER
NATE HINZ

CLIENT
MINNEAPOLIS CHILDREN'S THEATER

DESIGN CO.
DESIGN ARMY

ART DIRECTOR
JAKE LEFEBURE & PUM LEFEBURE

DESIGNER
PUM LEFEBURE

CLIENT
THE WASHINGTON BALLET

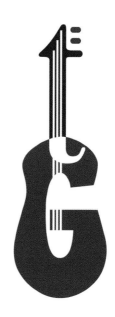

1

DESIGN CO.
SQUARE1STUDIO

ART DIRECTOR
RON J. PRIDE

DESIGNER
RON J. PRIDE

CLIENT
TONY GABRIEL

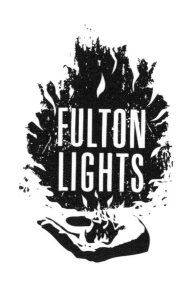

DESIGN CO.
FUSZION

DESIGNER
JOHN FOSTER

CLIENT
FULTON LIGHTS

2

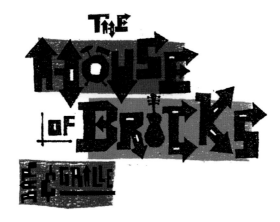

1

2

DESIGN CO.
SAYLES GRAPHIC DESIGN

ART DIRECTOR
JOHN SAYLES

DESIGNER
JOHN SAYLES

CLIENT
HOUSE OF BRICKS BAR & GRILLE

DESIGN CO.
MCINTOSH CREATIVE

ART DIRECTOR
CLAY MCINTOSH

DESIGNER
CLAY MCINTOSH

CLIENT
LIES THAT RHYME MUSIC

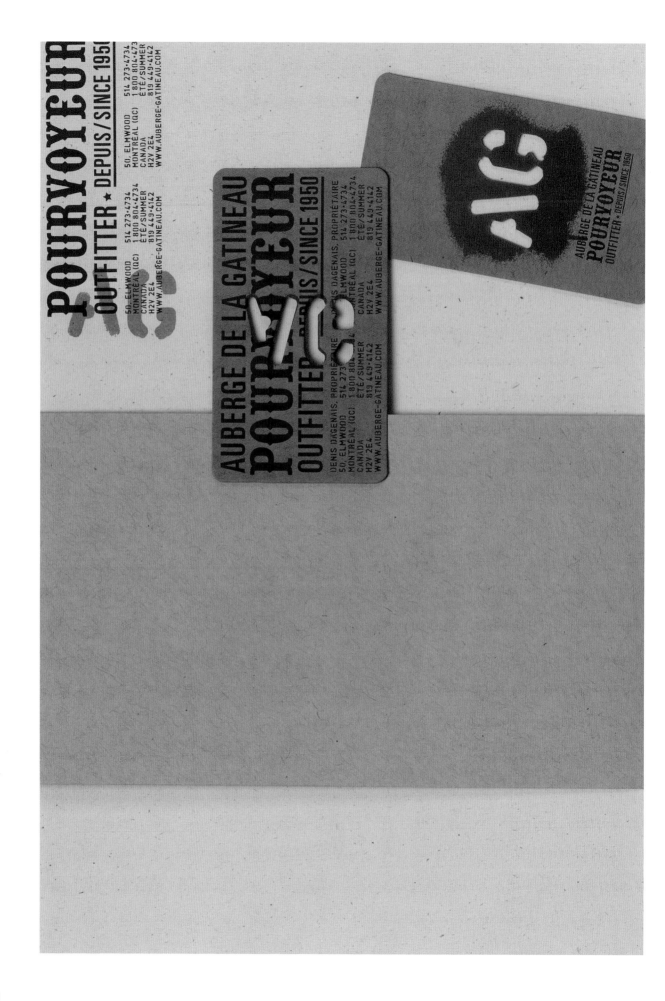

DESIGN CO.
PAPRIKA

ART DIRECTOR
LOUIS GAGNON

DESIGNER
RICHARD BELANGER &
FRANCOIS LECLERC

CLIENT
AUBERGE DE LA GATINEAU

DESIGN CO.
OCTAVO DESIGN

ART DIRECTOR
GARY DOMONEY

DESIGNER
GARY DOMONEY

CLIENT
GLUTTONY RESTAURANT BAR

DESIGN CO.
LLOYDS GRAPHIC DESIGN LTD.

ART DIRECTOR
ALEXANDER LLOYD

DESIGNER
ALEXANDER LLOYD

CLIENT
LLOYDS GRAPHIC DESIGN LTD.

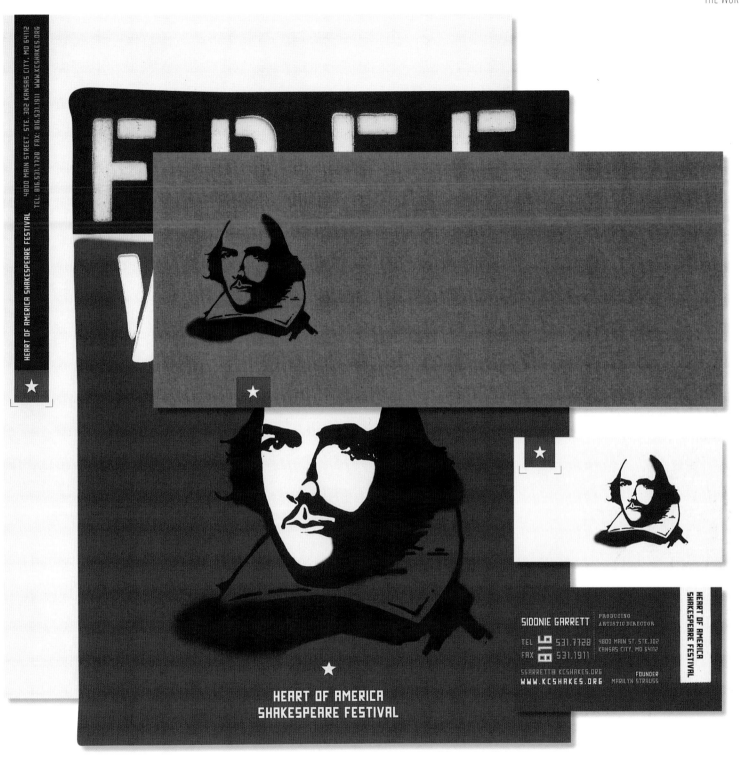

HEART OF AMERICA
SHAKESPEARE FESTIVAL

SIDONIE GARRETT
PRODUCING
ARTISTIC DIRECTOR

TEL **816** 531.7728
FAX **816** 531.1911

4800 MAIN ST. STE.302
KANSAS CITY, MO 64112

SGARRETT@KCSHAKES.ORG
WWW.KCSHAKES.ORG

FOUNDER
MARILYN STRAUSS

HEART OF AMERICA
SHAKESPEARE FESTIVAL

HEART OF AMERICA SHAKESPEARE FESTIVAL 4800 MAIN STREET, STE. 302 KANSAS CITY, MO 64112 TEL: 816.531.7728 FAX: 816.531.1911 WWW.KCSHAKES.ORG

DESIGN CO.
BR: VERSE

ART DIRECTOR
NATHANIEL COOPER

DESIGNER
NATHANIEL COOPER

CLIENT
HEART OF AMERICA SHAKESPEARE FESTIVAL

1

DESIGN CO.
TOKY BRANDING + DESIGN

ART DIRECTOR
ERIC THOELKE

DESIGNER
KARIN SOUKUP

CLIENT
OPERA THEATRE OF SAINT LOUIS

DESIGN CO.
ROCKETDOG COMMUNICATIONS

ART DIRECTOR
SUSAN ELLIOTT

DESIGNER
SUSAN ELLIOTT

2

CLIENT
TATTOO LA FEMME

1

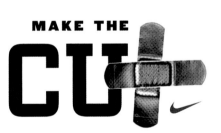

2

DESIGN CO.
MONO

DESIGNER
TRAVIS OLSON

CLIENT
ROLAND EIDAHL

DESIGN CO.
MINT DESIGN INC.

ART DIRECTOR
MIKE CALKINS & RYAN JACOBS

DESIGNER
MIKE CALKINS

CLIENT
NIKE

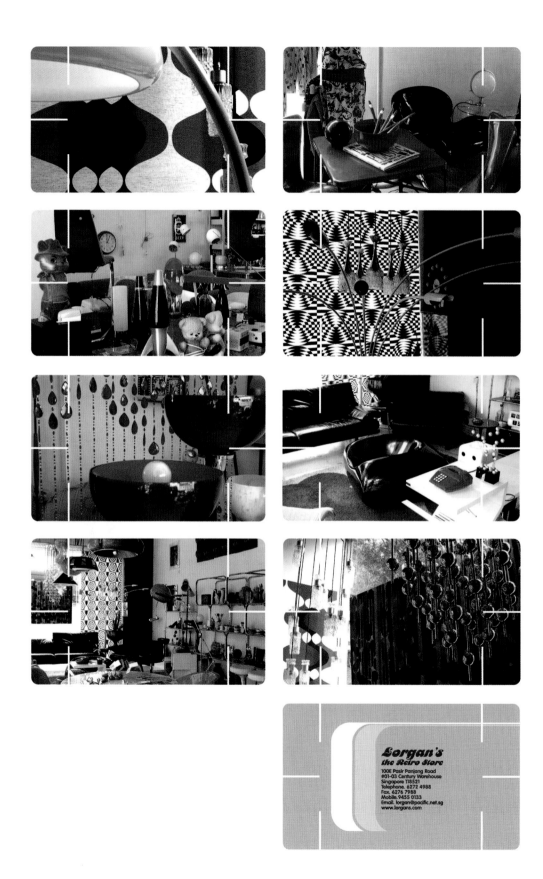

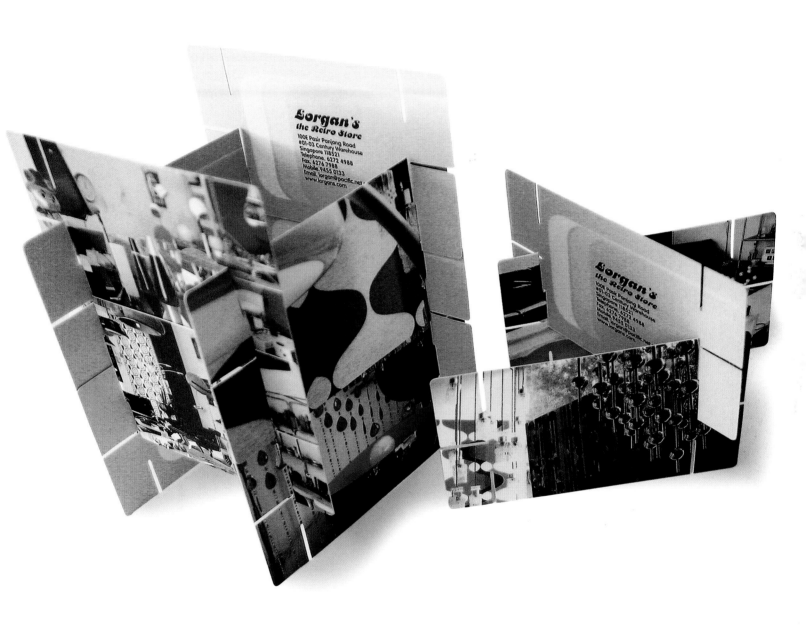

DESIGN CO.
KINETIC

ART DIRECTOR
PANN LIM & ROY POH

DESIGNER
ROY POH

CLIENT
LORGAN'S THE RETRO STORE

RUTH

PROPR

CHATEAU

ANTIQUITÉS ARCHITECTUR

3615B WEST ALABAMA,
TELEPHONE 713.961.3444

WWW.CHATEAU

C D

CHATEAU DOMINGUE
ANTIQUITÉS ARCHITECTURALES *et* MONUMENTALES

3615B WEST ALABAMA, HOUSTON, TEXAS 77027
TELEPHONE 713.961.3444 FACSIMILE 713.961.3495
WWW.CHATEAUDOMINGUE.COM

DESIGN CO.
RIGSBY DESIGN

ART DIRECTOR
THOMAS HULL & LANA RIGSBY

DESIGNER
THOMAS HULL & DANIEL PAGAN

CLIENT
CHATEAU DOMINGUE

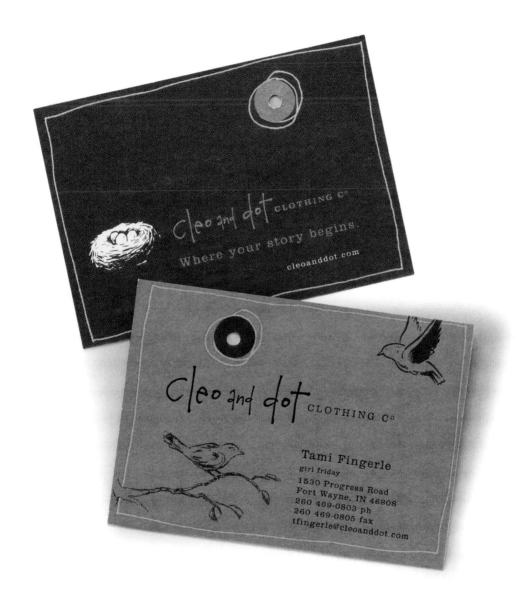

DESIGN CO.
ONE LUCKY GUITAR

ART DIRECTOR
MATT KELLEY

DESIGNER
MATT KELLEY

CLIENT
CLEO AND DOT CLOTHING CO.

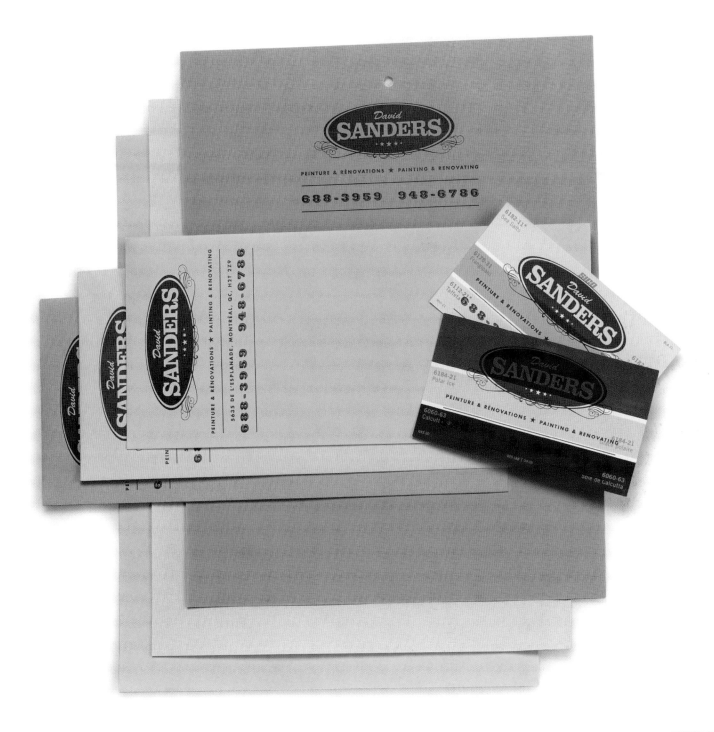

DESIGN CO.
PAPRIKA

ART DIRECTOR
LOUIS GAGNON

DESIGNER
SEBASTIEN BISSON

CLIENT
DAVID SANDERS

RP-0218-3184

RP-0218-3188

RP-0218-3276

RP-0218-1356

RP-0218-2772

RP-0218-2856

RP-0218-2940

RP-0218-2773

THE DIRECTORY

3rd Edge Communications
162 Newark Avenue
Jersey City, NJ 07302 USA
T: 201-395-9960
F: 201-395-0044
rob@3rdedge.com
153

28 Limited Brand
Bessemerstrasse 85, Halle 8
Bochum, NRW 44793 Germany
T: +49 234-916095-1
F: +49 234-916095-2
mail@twenty-eight.de
135

344 Design, LLC
USA
T: 626-796-5748
stefan@344design.com
133

A3 Design
PO Box 43046
Charlotte, NC 28215 USA
T: 704-568-5351
alan@atthreedesign.com
26, 127, 140, 174

A Little Birdie Design Studio
5/68 Gray Street
Mount Gambier, SA 5290 Australia
T: +61 8-8723-4477
info@alittlebirdiedesign.com.au
121

Anne Johnson
Vincent, OH 45784 USA
T: 304-424-3517
amjohnson@falhgren.com
171

Annie Sullivan
169 Engert Avenue, #2
Brooklyn, NY 11222 USA
T: 718-902-8675
asullivan19@yahoo.com
127

Archrival
720 O Street, Lot A
Lincoln, NE 68508 USA
T: 402-435-2525
F: 402-435-8937
carey@archrival.com
30, 38, 89, 202

A-Sign
Schloss Girsberg
Kreuzlingen, Thurgau 8280
Switzerland
T: +41 71-672-1800
F: +41 71-671-2393
info@a-sign.ch
134

Bamboo
119 North 4th Street, Suite 503
Minneapolis, MN 55401 USA
T: 612-332-1817
F: 612-332-7101
shane@bamboo-design.com
94, 100, 126, 157, 196, 197

Beganik
308 Prince Street, Suite 234
Saint Paul, MN 55101 USA
T: 651-488-7900
F: 651-209-8060
dustin@beganik.com
201

Bidwell ID
30 N. Maple Street, Suite 2
Florence, MA 01062 USA
T: 413-585-9387
F: 413-585-9217
lilly@bidwellid.com
73

Blok Design
Sombrerete 515#7
Col. Condesa
Mexico DF, Mexico 06170 Mexico
T: 5255-5515-24-23
F: 5255-5515-24-23
ve@blokdesign.com
184

Blue Tricycle
3609 41st Avenue South
Minneapolis, MN 55406 USA
T: 612-729-2372
info@bluetricycle.com
103, 127

Bob Dinetz Design
236 Bonita Avenue
Piedmont, CA 94611 USA
T: 415-606-6792
bob@bobdinetzdesign.com
113

br: verse
4600 Madison Avenue
Kansas City, MO 64112 USA
T: 816-960-5256
F: 816-960-5588
Chuck_hoffman@bradv.com
24, 43, 67, 120, 186, 187, 199, 221

Burton Corporation
80 Industrial Parkway
Burlington, VT 05401 USA
T: 802-652-3777
F: 802-652-3767
tobyg@burton.com
65, 77, 96, 118, 132, 140, 188, 189

Calagraphic Design
523 Stahr Road
Elkins Park, PA 19027 USA
T: 215-782-1361
rcala@temple.edu
88

Campbell Fisher
401 E. Jefferson Street
Phoenix, AZ 85004 USA
T: 602-462-6500
F: 602-462-6600
dalkire@dbacks.com
62

Capsule
10 South 5th Street, Suite 645
Minneapolis, MN 55402 USA
T: 612-341-4525
F: 612-341-4577
alosinski@capsule.us
105, 138, 139, 146, 198

Carmichael Lynch Thorburn
110 North 5th Street
Minneapolis, MN 55403 USA
T: 612-375-8204
F: 612-334-6085
jessica.sutton@clynch.com
90, 122, 147, 179

Campbell Fisher
3333 E. Camelback Rd. Suite 300
Phoenix, AZ 85018 USA
T: 602-955-2707
gf@thinkcfd.com
62

Catalyst Studios
126 North 3rd Street Suite 200
Minneapolis, MN 55404 USA
T: 612-339-0735
F: 612-339-0739
ellen@catalyststudios.com
80, 81, 177, 178

CDI Studios
2251a Renaissance Drive
Las Vegas, NV 89119 USA
T: 702-876-3316
F: 702-876-3317
dan@cdistudios.com
50

Cloudtheory
150 School Street
Somerville, MA 02143 USA
T: 617-314-9530
jenniwon@cloudtheory.com
71

Colle + McVoy
400 First Avenue North, Suite 700
Minneapolis, MN 55401 USA
T: 612-305-6169
F: 612-305-6500
kristen.evanoff@collemcvoy.com
32, 33, 78, 119, 152, 208

Cue, Inc.
430 North First Avenue, Suite 200
Minneapolis, MN 55401 USA
T: 612-465-0030
F: 612-465-0039
acolvin@designcue.com
26, 112, 136, 143, 215

Daniel P. Johnston / Anna Simutis
327 East 3rd Street, No. 4C
New York, NY 10009 USA
T: (DJ) 206-313-0427
T: (AS) 646-413-9575
daniel@danielpjohnston.com
annasimutis@yahoo.com
98

Demiurge Unit Limited
22/ F Empress Plaza
17-19 Chatham Road South
Kowloon, Hong Kong Sar
T: +852 2199-4001
F: +852 2144-2633
catherine@ledartist.com
97

Deniz Marlali
81 Belair Road
Staten Island
New York, NY 10305 USA
T: 347-698-5773
dmarlali@gmail.com
91

Design Army
1312 9th Street, NW, Suite 200
Washington, D.C. 20001 USA
T: 202-797-1018
F: 202-478-1807
pum@designarmy.com
26, 68, 69, 141, 156, 176, 215

Designbolaget
Ryesgade 3F, 2
Copenhagen N 2200 Denmark
T: +45 26-83-87-15
due@designbolaget.dk
22

Design Guys
119 North 4th Street, Suite 400
Minneapolis, MN 55401 USA
T: 612-338-4462
F: 612-338-1875
deb@Design Guys.com
175

Design Ranch
1600 Summit
Kansas City, MO 64108 USA
T: 816-472-8668
F: 816-472-8778
tc@design-ranch.com
29, 31, 47, 106, 108, 109, 129, 190,
191, 206

Dotzero Design
208 SW Stark Street, #307
Portland, OR 97204 USA
T: 503-892-9262
jonw@dotzerodesign.com
25, 122

eighthourday
1618 Central Avenue NE, Suite 125
Minneapolis, MN 55413 USA
T: 612-788-9098
katie@eighthourday.com
23, 53, 156

Fauxkoi Design Co.
3853 14th Avenue S
Minneapolis, MN 55407 USA
T: 612-251-4277
dan@fauxkoi.com
27, 155, 190

Firebelly Design
2701 W Thomas Street, 2nd Floor
Chicago, IL 60622 USA
T: 773-489-3200
F: 773-489-3439
info@firebellydesign.com
207

Fox Creative
2365 South 500 East
Salt Lake City, UT 84106 USA
T: 801-243-4518
afox@insidethefox.com
199

Fuszion
901 Prince Street
Alexandria, VA 22314 USA
T: 703-548-8080
F: 703-548-8382
john@fuszion.com
72, 88, 102, 216

Gee + Chung Design
38 Bryant Street, Suite 100
San Francisco, CA 94105 USA
T: 415-543-1192
F: 415-543-6088
earl@geechungdesign.com
102

Giotto
Juan González N35-135
Edf. Metropoli Of. 606
Quito, Pichincha 17-17-712 Ecuador
T: +593 2-2461075
F: +593 2-2461075
info@giottodesign.com
180, 193

Go Welsh
987 Mill Mar Road
Lancaster, PA 17601 USA
T: 717-569-4040
F: 717-569-3707
cwelsh@gowelsh.com
22, 24, 123, 213

Graphiculture
322 First Avenue North, Suite 500
Minneapolis, MN 55401 USA
T: 612-339-8271
F: 612-339-1436
info@graphiculture.com
52, 95, 145

Greteman Group
1425 East Douglas, 2nd Floor
Wichita, KS 67211 USA
T: 316-263-1004
F: 316-263-1060
cfarrow@gretemangroup.com
90, 94, 117, 165

Gulla Design
62 Gates Avenue
Montclair, NJ 07042 USA
T: 973-746-5604
F: 973-746-8652
info@gulladesign.com
103, 176

Hartford Design
954 West Washington, 4th Floor
Chicago, IL 60607 USA
T: 312-563-5600
F: 312-563-5603
tim@hartforddesign.com
23, 47, 48, 51, 116

Hartung Kemp
1128 Harmon Place, Suite 200
Minneapolis, MN 55403 USA
T: 612-343-8880
F: 612-343-1021
aisling@hartungkemp.com
84

Imagehaus
12 South 6th Street, Suite 614
Minneapolis, MN 55402 USA
T: 612-377-8700
F: 612-374-2956
Jamie@imagehaus.net
55, 74, 75, 121, 213

Industrio
4401 31st Avenue S
Minneapolis, MN 55406 USA
T: 612-423-0014
allan@malcolmcreative.com
46

Initio
212 Third Avenue North, Suite 510
Minneapolis, MN 55401 USA
T: 612-339-7195
F: 612-333-0632
joe@initioadvertising.com
79, 112, 117, 123, 125, 130, 131, 214

Johnston Duffy
803 S. 4th Street, First Floor
Philadelphia, PA 19147 USA
T: 215-389-2888
F: 215-389-2889
martin@johnstonduffy.com
82

KAA Design Group, Inc.
4201 Redwood Avenue
Los Angeles, CA 90066 USA
T: 310-821-1400
F: 310-821-1440
ccheng@kaadesigngroup.com
192

Kinetic
2 Leng Kee Road
#03-02
Thye Hong Centre, Singapore 159086
T: +65 63795792
F: +65 64796802
roy@kinetic.com.sg
28, 58, 59, 64, 160, 224, 225

Korn Design
116 St. Botolph Street
Boston, MA 02115 USA
T: 617-266-8112
F: 617-266-5427
info@korndesign.com
168

Kota Design
92 Justins Way
Falling Waters, WV 25419 USA
T: 304-274-0460
F: 304-274-0460
square1studio@gmail.com
65, 216

Lewis Communications
30 Burton Hills Boulevard, Suite 207
Nashville, TN 37215 USA
T: 615-661-4995
F: 615-661-4772
clarkh@lewiscommunications.com
34, 35, 36, 91, 178, 200

Limb Design
7026 Old Katy Road, Suite 350
Houston, TX 77024 USA
T: 713-529-1117
F: 713-529-1558
linda@limbdesign.com
114, 115

Little and Company
920 Second Avenue S, Suite 1400
Minneapolis, MN 55402 USA
T: 612-375-0077
F: 612-375-0423
rachel.meier@littleco.com
165

Lloyds Graphic Design Ltd.
17 Westhaven Place
Blenheim, Marlborough 7201
New Zealand
T: +64 3-5786955
F: +64 3-5786955
lloydgraphics@xtra.co.nz
220

Lovely
NKB Studio 455
1500 Jackson Street NE
Minneapolis, MN 55413 USA
T: 608-213-4391
Kevin@lovelympls.com
124, 212

Marius Fahrner Design
Neuer Kamp 25
Hamburg, 20359 Germany
T: +49 177-23-82-777
F: +49 40-412-88-278
info@mariusfahrner.com
37, 104, 182, 209

McIntosh Creative
3919 East 4th Street
Tulsa, OK 74112 USA
T: 918-691-7032
cpmcok@yahoo.com
217

Mine™
190 Putnam Street
San Francisco, CA 94110 USA
T: 415-647-6463
F: 415-647-6468
cchs@minesf.com
27, 85, 106, 169, 183, 195

Mint Design Inc.
111 W. John Street No. 203
Seattle, WA 98119 USA
T: 206-957-0464
F: 206-749-5015
ryanjacobs@mint-usa.com
53, 120, 212, 223

Miriello Grafico
419 West G Street
San Diego, CA 92101 USA
T: 619-234-1124
F: 619-234-1960
pronto@miriellografico.com
46, 101, 152

Modern Dog Design Co.
7903 Greenwood Avenue N
Seattle, WA 98103 USA
T: 206-789-7667
F: 206-789-3171
bubbles@moderndog.com
113, 149

mono
2902 Garfield Avenue South
Minneapolis, MN 55408 USA
T: 612-822-4135
F: 612-822-4136
eschumacher@mono-1.com
76, 79, 141, 204, 205, 223

Octavo Design Pty Ltd.
11 Yarra Street
South Melbourne, VIC 3205
Australia
T: +61 3 9686-4703
F: +61 3 9686-4704
info@octavodesign.com.au
164, 219

One Lucky Guitar
1301 Lafayette Street Suite 201
Fort Wayne, IN 46802 USA
T: 260-969-6672
matt@oneluckyguitar.com
162, 163, 194, 227

Paprika
400, Laurier Ouest, #610
Montréal, PQ H2V 2K7 Canada
T: 514-276-6000
F: 514-276-6100
info@paprika.com
20, 21, 40, 41, 83, 210, 211, 218, 228, 229

Parachute Design
120 South 6th Avenue, Suite 1200
Minneapolis, MN 55402 USA
T: 612-359-4363
F: 612-359-4390
slien@parachutedesign.com
47, 49, 60, 61, 71, 94, 99

Partly Sunny
2221 NW 56th Street, Suite 102
Seattle, WA 98107 USA
T: 206-789-3359
info@patsnavely.com
128

PBJs
2226 3rd Avenue
Seattle, WA 98121 USA
T: 206-464-8392
F: 206-344-5210
ericw@pbjs.com
27

Periscope
921 Washington Avenue South
Minneapolis, MN 55415 USA
T: 612-399-0667
F: 612-399-0600
jbodell@periscope.com
46, 62

Philippe Archontakis
5685 6th Avenue
Montréal, PQ H1Y 2R1 Canada
T: 514-909-3122
design@philippearchontakis.com
92, 93

Pink Pear Design Company, The
3004 South Ponca Drive
Independence, MO 64057 USA
T: 816-519-7327
sarah@pinkpear.com
39, 181

Principle, Inc.
65 Aberdeen Street
Québec City, QC G1R 2C6 Canada
T: 418-522-1487
F: 418-948-8998
pamela@designbyprinciple.com
66, 158, 159

Ramp
411 South Main Street, Suite 615
Los Angeles, CA 90013 USA
T: 213-623-7267
michael@rampcreative.com
54, 154, 172, 179

Rickabaugh Graphics
384 West Johnstown Road
Gahanna, OH 43230 USA
T: 614-337-2229
F: 614-337-2197
rickabaugh@columbus.rr.com
25, 63, 95, 119

Rigsby Design
2309 University Boulevard
Houston, TX 77005 USA
T: 713-660-6057
F: 713-660-6057
dpagan@rigsbydesign.com
226

RocketDog Communications
911 Western Avenue, Suite 230
Seattle, WA 98104 USA
T: 206-254-0248
F: 206-254-0238
mikee@rocketdog.org
176, 222

Rubin Cordaro Design
115 North 1st Street
Minneapolis, MN 55401 USA
T: 612-343-0011
F: 612-343-0012
j.cordaro@rubincordaro.com
97

Ryan Carlson
5912 Upton Avenue South
Minneapolis, MN 55410 USA
T: 612-280-8194
ryan@twinsix.com
72, 118

Ryan Carlson and Brent Gale
5912 Upton Avenue South
Minneapolis, MN 55410 USA
T: 612-280-8194
ryan@twinsix.com
78

Ryan Cooper Design
15859 E Jamison Drive Apt. 12204
Englewood, CO 80112 USA
T: 303-917-9911
ryan@visualchili.com
70, 169

Sayles Graphic Design
3701 Beaver Avenue
Des Moines, IA 50310 USA
T: 515-279-2922
F: 515-279-0212
sheree@saylesdesign.com
42, 51, 144, 217

Segura Inc.
1110 North Milwaukee Avenue
Chicago, IL 60622 USA
T: 773-862-5667
F: 773-862-1214
carlos@segura-inc.com
22, 23, 106

Shine Advertising Co.
612 West Main Street
Madison, WI 53703 USA
T: 608-442-7373
F: 608-442-7374
tbliven@shinenorth.com
36, 44, 45, 142, 166, 167, 170

Sockeye Creative
800 NW 6th Avenue, Suite 211
Portland, OR 97209 USA
T: 503-226-3843
F: 503-227-1135
rwees@sockeyecreative.com
57

So Design Co.
P.O. Box 581308
Minneapolis, MN 55458 USA
T: 612-338-5720
mickey@sodesignco.com
161, 164, 185

Sommese Design
100 Rose Drive
Port Matilda, PA 16870 USA
T: 814-353-1951
F: 814-863-8706
lannys@psu.edu
203

Space150
212 3rd Avenue N, Suite 150
Minneapolis, MN 55401 USA
T: 612-332-6458
F: 612-332-6469
heidi@space150.com
150, 151

Spark Communications
327 East Maryland Avenue
Royal Oak, MI 48067 USA
T: 248-545-9012
F: 248-545-9244
sherri@spark-communications.com
36

Synergy Graphix
183 Madison Avenue, Suite 415
New York, NY 10016 USA
T: 212-968-7567
rstrada@synergygraphix.com
31, 96

Tim Frame Design
P.O. Box 3
Cedarville, OH 45314 USA
T: 614-598-0113
F: 614-388-5616
tframe@timframe.com
142, 143

Tomko Design
6868 North 7th Avenue, Suite 210
Phoenix, AZ 85022 USA
T: 602-412-4002
F: 602-476-2103
mike@tomkodesign.com
86, 87

TOKY Branding + Design
3139 Olive Street
St. Louis, MO 63103 USA
T: 314-534-2000
F: 314-534-2001
info@toky.com
48, 49, 56, 180, 222

True North
Fourways House
57 Hilton Street
Manchester M1 2EJ UK
T: +44 161-909-5444
F: +44 161-909-5445
info@thisistruenorth.co.uk
107

Turnstyle
2219 NW Market Street
Seattle, WA 98107 USA
T: 206-297-7350
F: 206-297-7390
steve@turnstylestudio.com
137

urbanINFLUENCE design studio
423 2nd Avenue, Ext. South, Suite 32
Seattle, WA 98104 USA
T: 206-219-5599
F: 206-973-5350
henry@urbaninfluence.com
110, 111, 144, 173

Urban Sketch
523 Jackson Street 218
St. Paul, MN 55101 USA
T: 612-202-0259
adam@urbansketch.com
181

WestmorelandFlint
11 East Superior Street, Suite 514
Duluth, MN 55802 USA
T: 218-727-1552
F: 218-733-0463
kenz@westmorelandflint.com
95, 116, 125, 214

A VERY SPECIAL THANK YOU TO:

ALL OF THE DESIGNERS WHO SUBMITTED SUCH EXCELLENT WORK FOR CONSIDERATION.

DAVID MARTINELL, EMILY POTTS, AND WINNIE PRENTISS AT ROCKPORT PUBLISHERS.

THOMASINE ELLIOT-KNIGHT AND KATHY SUSSNER FOR LOGGING 2,500 ENTRIES.

JEFF MUELLER AT FLOATING HEAD FOR PUTTING OUR THOUGHTS INTO WORDS.

FORMER SDCO EMPLOYEES FOR HELPING SHAPE OUR COMPANY IDENTITY:
RALPH SCHRADER, ROCHELLE SCHULTZ BRANCATO, RYAN CARLSON, BRENT GALE,
JEFF AKERVIK, AND CJ MARXER.
– – – – – – – –
THE CURRENT ROSTER AT SUSSNER DESIGN CO. WHO CONTRIBUTED TO L&L10 INCLUDES
DEREK SUSSNER (ART DIRECTOR), BRANDON VAN LIERE (LEAD DESIGNER ON THE BOOK),
TESSA SUSSNER, PEET FETSCH, AND BILL BURNS.
– – – – – – – –